PAINTING REALISTIC WATERCOLOR TEXTURES

PAINTING REALISTIC WATERCOLOR TEXTURES

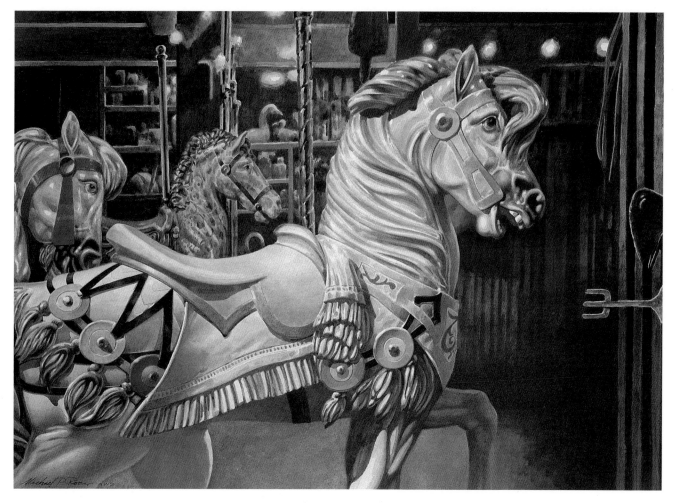

MICHAEL P. ROCCO

NORTH LIGHT BOOKS
CINCINNATI, OHIO

ABOUT THE AUTHOR

Michael P. Rocco attended the Pennsylvania Academy of the Fine Arts where he studied under such renowned artists as John McCoy, Francis Speight and Daniel Garber. His schooling was interrupted during the Second World War, serving in the military and seeing action in Italy. After completing his schooling, he used his creative talents in the commercial art field, but his first love has always been watercolor. He is a signature member of the American Watercolor Society, the Philadelphia Water Color Club, and the Allied Artists of America to name a few. He has had over thirty one-man exhibits, and his work is in many private collections. His paintings have been reproduced on calendars and art publications, including *Le Revue Moderne* of Paris, France; *Splash 1* and *Splash 2*.

He holds strongly to his emotional, realistic approach to art, and a critic once wrote of his work: "an amazing illusionistic tour de force."

Painting Realistic Watercolor Textures. Copyright © 1996 by Michael P. Rocco. Printed and bound in China. All rights reserved. No part of this book may be reproduced in any form or by any electronic or mechanical means including information storage and retrieval systems without permission in writing from the publisher, except by a reviewer, who may quote brief passages in a review. Published by North Light Books, an imprint of F&W Publications, Inc., 1507 Dana Avenue, Cincinnati, Ohio 45207. (800) 289-0963. First edition.

Other fine North Light Books are available from your local bookstore, art supply store or direct from the publisher.

00 99 98 97 96 5 4 3 2 1

Library of Congress Cataloging-in-Publication Data

Rocco, Michael P.
 Painting realistic watercolor textures / Michael P. Rocco.
 p. cm.
 Includes index.
 ISBN 0-89134-659-7 (alk. paper)
 1. Watercolor painting—Technique. 2. Texture (Art)—Technique.
 I. Title.
ND2422.R63 1996
751.42′2—dc20 95-20927
 CIP

Edited by Rachel Wolf and Kathryn Kipp
Cover and interior designed by Sandy Conopeotis Kent
Cover illustration by Michael P. Rocco

METRIC CONVERSION CHART		
TO CONVERT	TO	MULTIPLY BY
Inches	Centimeters	2.54
Centimeters	Inches	0.4
Feet	Centimeters	30.5
Centimeters	Feet	0.03
Yards	Meters	0.9
Meters	Yards	1.1
Sq. Inches	Sq. Centimeters	6.45
Sq. Centimeters	Sq. Inches	0.16
Sq. Feet	Sq. Meters	0.09
Sq. Meters	Sq. Feet	10.8
Sq. Yards	Sq. Meters	0.8
Sq. Meters	Sq. Yards	1.2
Pounds	Kilograms	0.45
Kilograms	Pounds	2.2
Ounces	Grams	28.4
Grams	Ounces	0.04

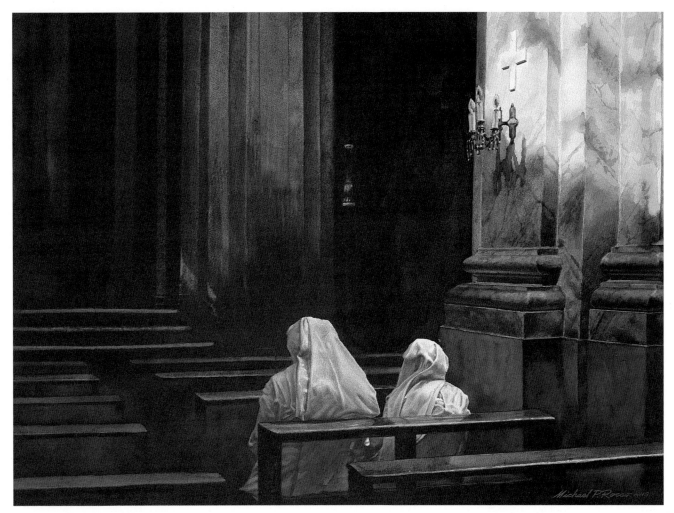

IN ZAFFERANA, SICILY
18″ × 24″

ACKNOWLEDGMENTS

I would be remiss not to remember Mr. Mock and Mr. Early, my high school instructors who are no longer with us but were instrumental in my receiving a four-year scholarship to art school. My thanks to Rachel Wolf, my editor, for her guidance and affording me this opportunity. To my wife Rita upon whose urgence I accepted this challenge. To my children Gregory and Michele who, along with my wife, have been supportive and understanding throughout my career. My heartfelt thanks to all of you.

Table of Contents

Introduction
viii
Materials • Color Palette • Composition

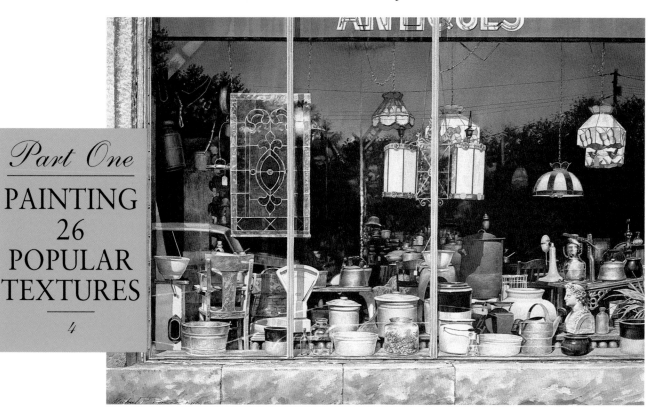

Part One

PAINTING
26
POPULAR
TEXTURES

4

Natural Textures

Man-Made Textures

Light and Shadow Textures

Still-Life Textures

Part Two

HANDS ON!
Eleven Complete Painting Demonstrations

78

Index
118

Introduction

Realism is the mainstay of the art world. It has been with us for ages and will last through the existence of man. In some art circles, realism seems to imply something passé, that artists who paint realistically are living in the past, or that realistic art lacks creativity.

That is not to say I am not moved by other schools of art. I look at the work of the Impressionists and feel the light they painted. Van Gogh's colors and technique stir me. He felt he could not draw—how wrong he was. Edward Hopper's bold compositions and the mood in his paintings made me an admirer.

I enjoy painting what I see, but I always attempt to go beyond a mere representation, to infuse an emotional impact upon the viewer, be it a feeling of snow or the dampness of a morning mist. Color must have meaning. There must be a difference in the representation of stone and wood. To paint an animal without feeling the pull of muscle or the texture of its hide would be a void.

In this book we will concentrate on my realistic, emotional approach to watercolor. We will cover a wide range of subject matter and many different textures, from the cold hardness of stone to the downy softness of feathers. By practicing the methods shown in the demonstrations, you may be inspired to paint any subject that comes your way.

MATERIALS
Watercolor Paper
There is a wide selection of quality papers that are made of 100 percent rag. These papers are acid free and buffered against environmental contamination. They last a long time without turning yellow. The lesser quality papers do not. Quality papers are superior in accepting washes, and the surface of these papers can withstand a certain amount of abuse. Most of these papers are mold-made, but their texture is random and gives better results than the patterned surface of lesser quality papers. It is better to paint on quality, though it may cost a bit more, for the workability is worth it.

Hot Press Surface. Smooth, slick surface. Difficult to control even washes. Excellent color depth and reflection. Textures require rendering. Does not absorb well.

Cold Press Surface. Medium textured surface. Accepts washes well with ease of control. Texture effects easily achieved. Good for drybrushing.

A cold press surface has all the requirements for my painting.

Rough Surface. Heavily grained surface. Accepts washes well but can dry spotty. Good absorption for wet-into-wet technique. Drybrushing quality good.

My Color Palette
I prefer tube colors for I like being able to squeeze fresh paint onto the palette rather than working dry pan color into a usable state. Tube color can be worked with a minimum of water to achieve an intensity that cannot be duplicated by pan color. I am able to mix color directly from tubes, as I would oils, which I feel is another advantage.

I mix colors to substitute for black, usually Sepia or Warm Sepia with any of the following: Permanent Blue, Payne's Gray or Neutral Tint. I use two rectangular plastic palettes. Each has eight slanted mixing compartments in line with the paint wells. The compartments prevent mixed colors from running into each other.

Brushes
Pure Kolinsky red sable brushes are undoubtedly the finest, but they are extremely expensive. It's possible to purchase relatively inexpensive but good quality brushes. Any brush should be tested before purchasing and a reputable art supply house will allow this. To test a round brush, wet the brush to see if it forms a good point. If the hair separates and cannot be formed properly, it's of inferior quality. Flick the brush. Does the body hold its shape? Is it full bodied? Will it hold a good amount of color? Do not paint with an inferior brush! It can cause grief and waste time.

I use a wide range of sizes in round brushes—nos. 2, 4, 6, 8, 10 and 12. I use a 1-inch flat brush for broad washes. Some old brushes I have trimmed to a few filaments for fine lines and others I have cut short for stippling.

Additional Items
Stencil Knife. A handy tool, especially in the field, for sharpening pencils and scraping color from the painting.

Lemon Yellow

Cadmium Yellow

Chrome Orange

Cadmium Red

Alizarin Crimson

Yellow Ochre

Raw Umber

Olive Green

Hooker's Green Deep

Burnt Sienna

Warm Sepia

Sepia

Cerulean Blue

Permanent Blue

Payne's Gray

Neutral Tint

Sponge. Preferably natural. Good for stippling texture.

Masking Liquid. A brush-on material that dries to a film impervious to water. Use when an area is to remain clear of color. Easily removed with a rubber cement pickup. Should be tested to assure it won't disturb the paper sizing.

My Color Palette
I use only the colors needed in the painting. For black I mix Sepia or Warm Sepia with any of the following: Permanent Blue, Payne's Gray, or Neutral Tint. My palettes are plastic and rectangular in shape with eight paint wells in line with slanted mixing compartments.

COMPOSITION

There are no hard and fast rules concerning composition save one: Avoid insignificance, triviality and disturbance.

Each artist has his or her own tastes that influence what he or she feels is correct. That is what creates individuality. What I see and how I choose to paint is mine and mine alone. I like to have my compositions "read" from left to right. This feels comfortable to me. If you scrutinize the paintings in this book, you'll find that is generally the case.

Compositional Elements

Composition is defined as "the organization of the parts of a work to achieve a unified whole." What are these parts? The basic elements I look at for good composition are space, dimension, depth, form, mood. We are limited to a flat surface of a given area to create these illusions.

Creating the Elements

Color and values are pertinent to all of the elements. Distance is often reflected in pale or hazy color but only if there is comparison to stronger color. A flat, tonal quality in a painting may produce mood, but add a few lights and darks and you have spatial relationships. Color can project or recede. Put yellow against a dark blue and the yellow leaps forward. Values and shadows give form and dimension. They tell us how large or deep an object is. They can make objects float in space or stay on the ground. With perspective we create size and space. For example, the barns in the diagrams at right are all of equal size. Perspective makes them appear different and gives depth. Perspective lines can also be used to lead the eye into and around the painting.

Composition is not merely a matter of directional lines, subliminal or otherwise, but an individualized balance of all the elements and images on your picture plane to obtain your desired effect. Or as the definition states, "parts of a work to achieve a unified whole." Plan your composition carefully. Make thumbnail sketches *before* you paint.

The Construction of a Composition

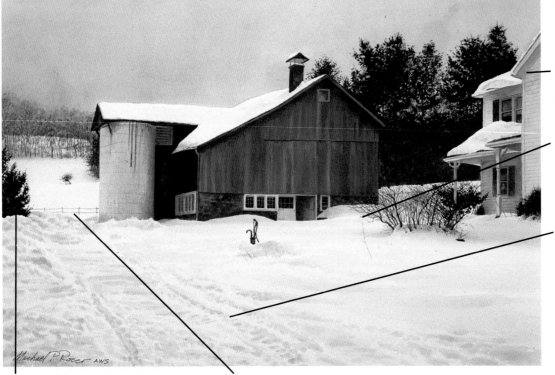

IN SULLIVAN COUNTY, 14″ × 21″

Diagonals of the eaves and siding force attention back to the barn.

Horizontal snow line causes the eye to move across the painting to investigate the porch.

Diagonal tracks lead slowly back into the field because they are a light value. If they were darker, like mud, they would command too much attention.

Important dark stops the eye from wandering off the edge.

Diagonals are stopped by the horizontal fence lines.

2

Compositional Mistakes

Using the same painting, *In Sullivan County,* I'll illustrate in these diagrams what I mean by "avoiding insignificance, triviality and disturbance."

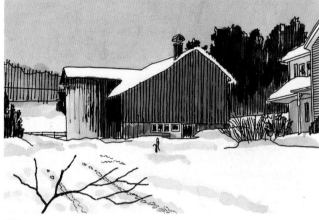

Wrong

The added branch at the lower left is trivial and meaningless to the painting. It commands too much attention.

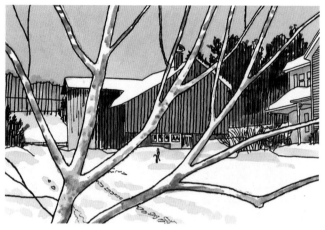

Better

This is an acceptable concept. Now the tree is a major part of the overall design. It does not stop the eye but urges the viewer to explore beyond it.

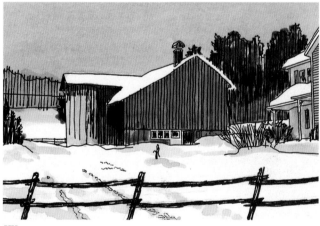

Wrong

The fence, seemingly a fitting detail for any farm scene, is obtrusive and not necessary.

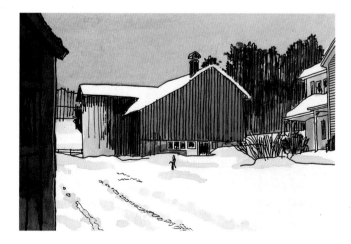

Better

This fence serves a meaningful purpose. It forms a directional line that allows the viewer to walk the path into the picture and does not distract from the original concept.

Wrong

This portion of a shed in the foreground is too confining and simply squeezes the painting. It adds nothing and should be eliminated.

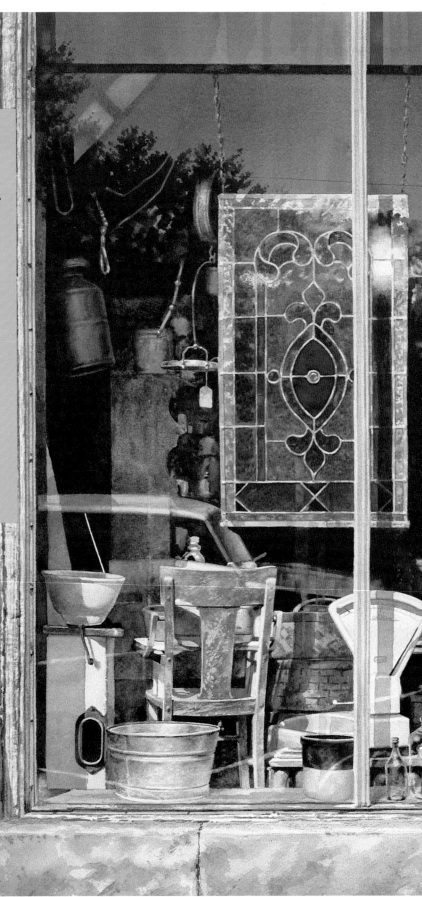

Part One

PAINTING 26 POPULAR TEXTURES

REFLECTIONS OF THE PAST, 21" × 29"

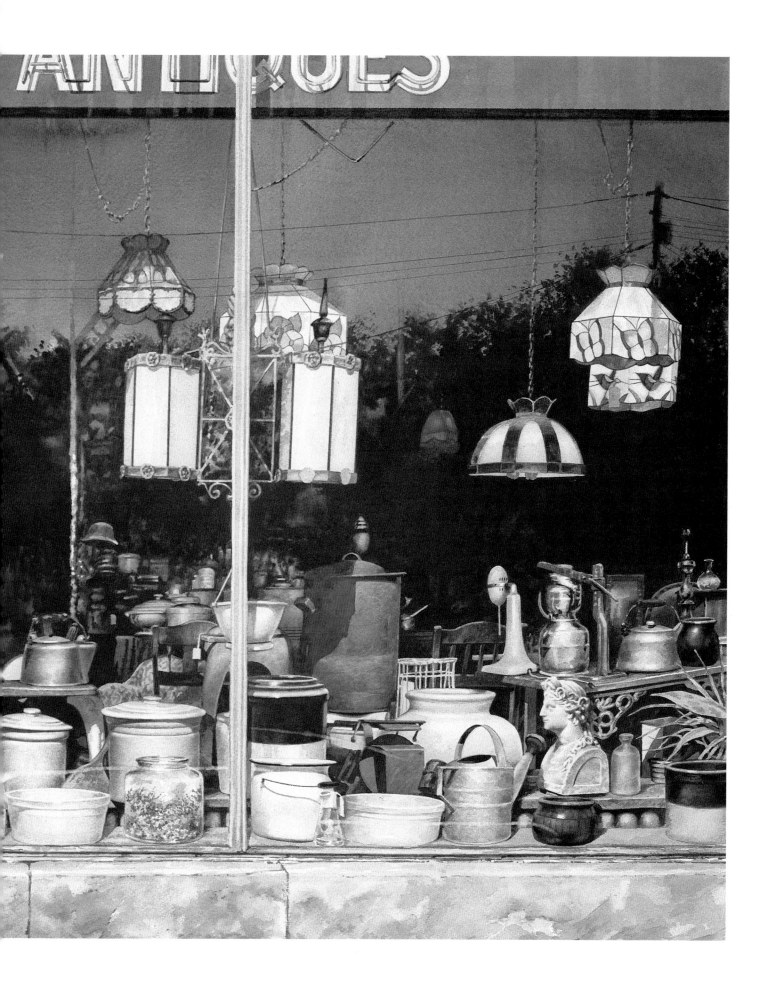

Apple Tree Leaves

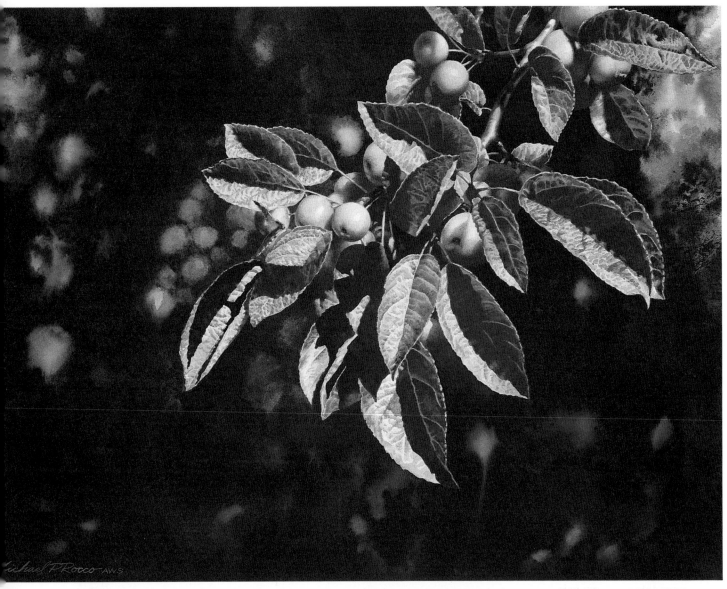

One beautiful autumn day my family and I visited an orchard to pick apples. While they were off deciding on the choicest, I roamed about with my camera. Upon viewing my slides, I chose to express myself in this painting. The contrasts and translucency of the leaves, as well as their texture, were impressive.

After drawing the composition, I painted a thin dark outline around all the contours, then proceeded to paint the entire background in one effort. This immediately established the contrasts and brilliance that I wanted. Some areas of the background were painted wet-into-wet, while others were heavily pigmented, but the color was kept flowing. No section was allowed to dry with a hard edge. I used a no. 12 round brush and a 1-inch flat brush for this broad area.

APPLE TREE
18" × 23"

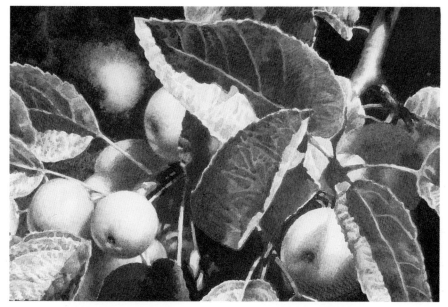

Detail of Apple Tree Leaves

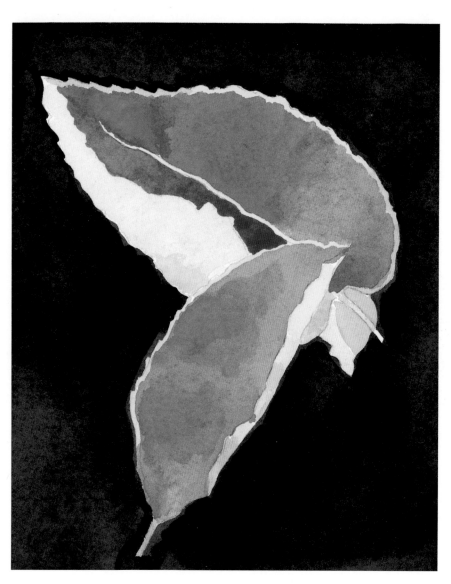

STEP 1

Starting with the upper leaf, paint the pale color in the lower half up to the central vein. Add the pale yellow to its edge and the edge of the lower leaf including the curl, then blend the changes of color. Let this dry. Now paint the shadow of the upper leaf with variations of color to give a translucent quality. Paint around the central vein so that the shadow below it becomes more intense. Treat the body of the lower leaf in the same manner. Add color to a small leaf in the back. Put in a dark background to help you establish contrasts.

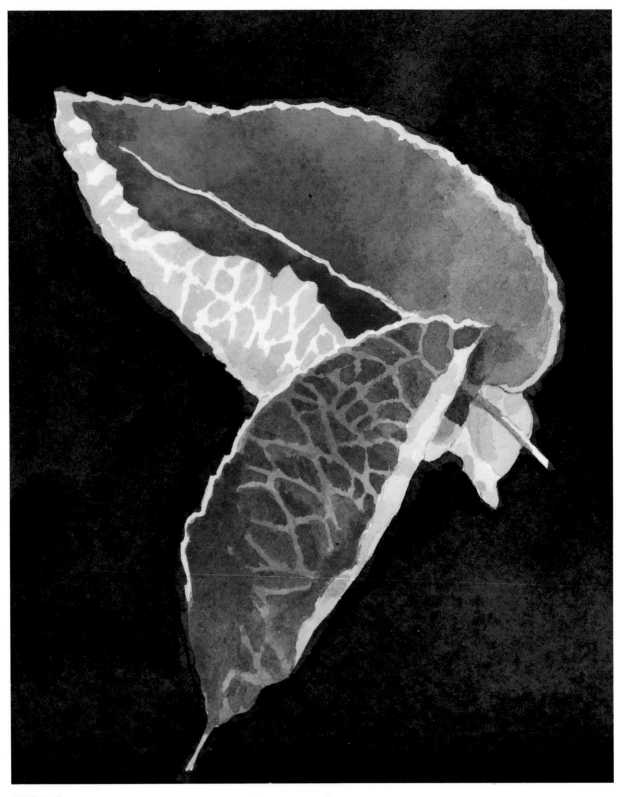

STEP 2

Start developing the tufting of the leaves by overlaying spots of intermediate color on the lighter washes to form veins. In some areas, this color is solid where shadow obliterates the detail. Where the leaves overlap, add changes of value and a shadow there and on the stem. With clean water, lighten a portion of the shadow on the upper leaf to increase the translucency. Then shade the small leaf.

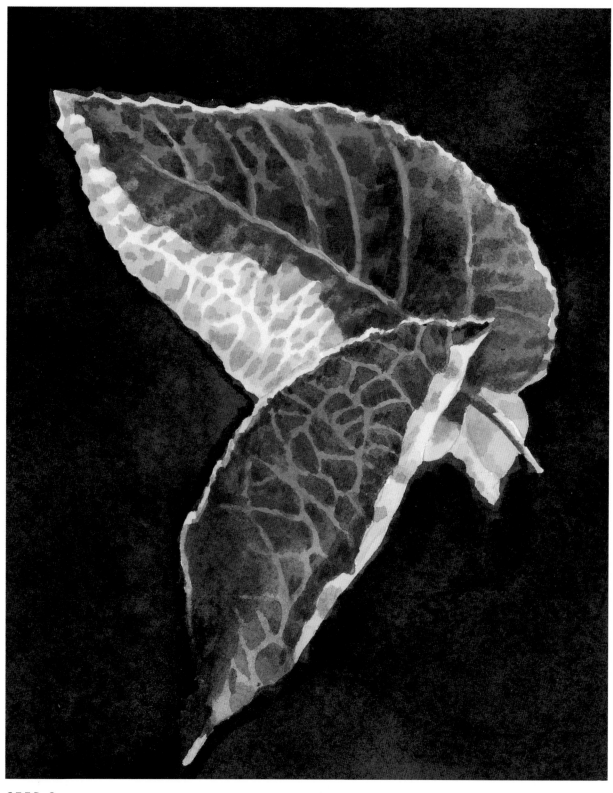

STEP 3

Accentuate the tufts with deeper values, which make the veins more obvious. Tone
down the central vein of the upper leaf, then clean away thin lines in its shadow
for tributaries. Form the tufts in the shadow with still deeper tones, and strengthen
shadows in the lower leaf to emphasize its curl.

Bare Branches

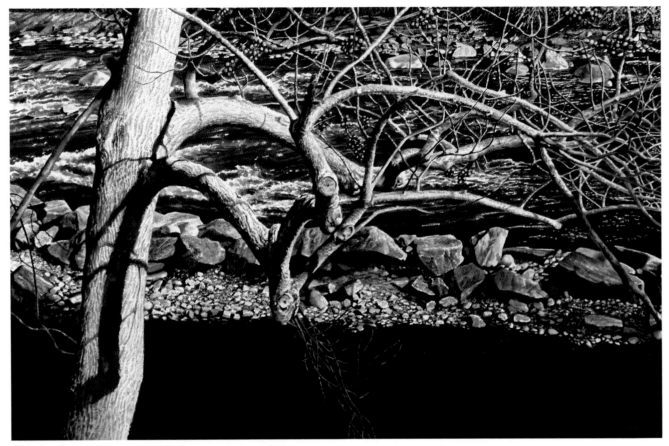

ALONG THE BRANDYWINE
14″ × 21″

What a challenge—having to look through the weblike configuration of tree branches to paint the rushing water and everything else beyond them, yet hold the composition together! I accomplished this by carefully drawing the tree, indicating branches that projected in front of others and important details. All other compositional lines were loosely handled—the ragged distant shoreline, the foreground finger of land, and some rocks in the river. Everything else was painted in, without any drawing, as I progressed. The entire background was painted to completion before I concentrated on the tree. An unorthodox way of painting, but it worked!

10

Detail of Bare Branches

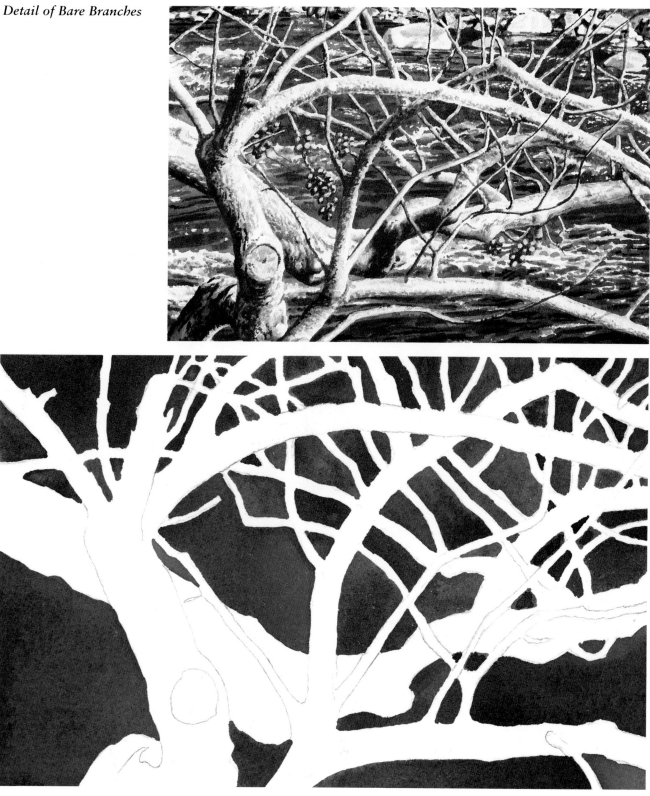

STEP 1

First paint in a very simple background. Although the background is cut into small pieces, keep a continuity through it all. By that I mean ripples, foam, shadows should flow properly behind the branches, and each section should belong to an adjacent one.

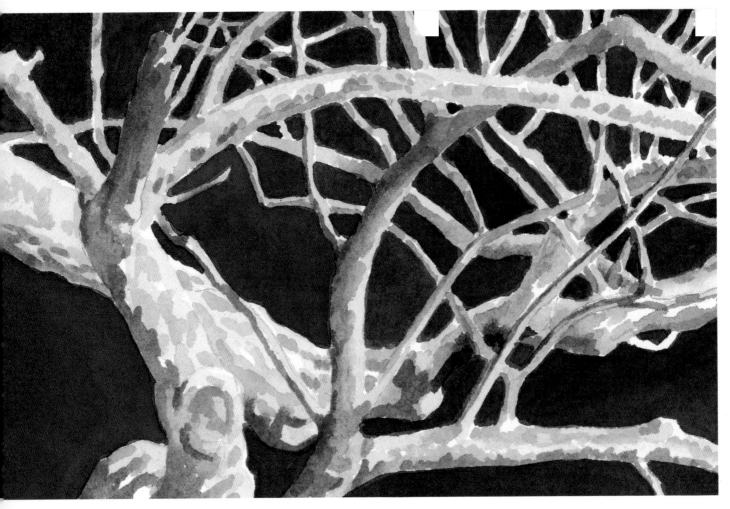

STEP 2

Unscramble the myriad of branches by painting the shadow side of major branches first, which enables you to follow their path. Also put in those sections that are completely in shadow and recede behind others. The values of your color should not be intense (think "reflected light" as you paint). Then add various pale colors to all the branches, blending some areas in wet for softness of shading and to give form to the limbs. Once dry, indicate the bark with slightly deeper values.

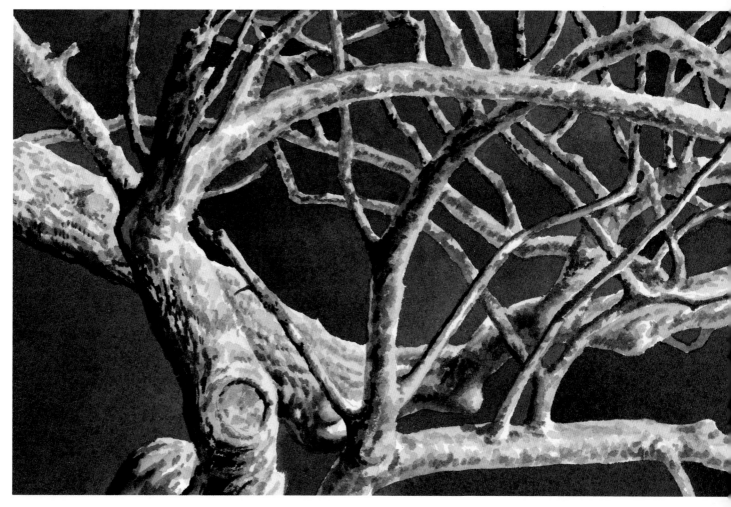

STEP 3

Drybrush more bark texture into all the branches, then ac-
cent its shadows. Work on the main part of the trunk, dry-
brushing texture, adding growth rings, strengthening shad-
ows to amplify the feeling of light. Accentuate the knob—
a small but important detail that focuses the eye away from
the confusion. Intensify shadows where necessary for
added depth and direction. Remember, branches grow out
of branches and should appear to do so in a painting. They
are always thicker at their point of origin, just like the trunk
growing up from the earth.

Clumpy Earth

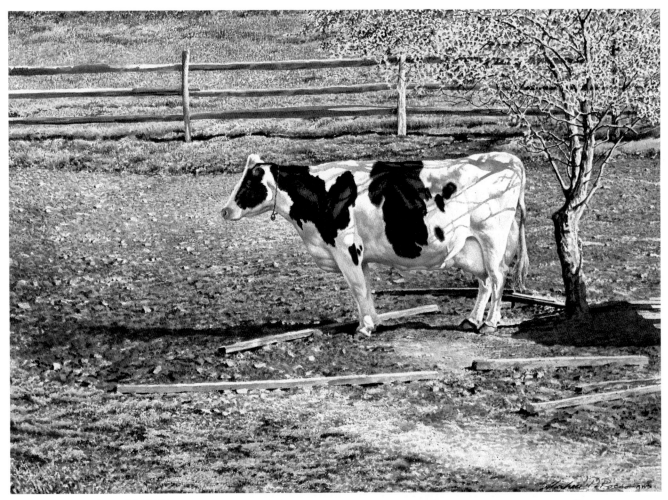

COW IN LANCASTER COUNTY
17″ × 23″

Out for a Sunday drive with my steady
companions, my wife and camera, I
came upon this cow standing away
from the rest of a small herd. It was a
warm day, so the cow turned its back
to the sun and stood in the meager
shade of the sparse tree. All it had to
do, I thought, was go back into the
barn for complete shade!

Detail of Clumpy Earth

STEP 1

Draw the image lightly on the watercolor sheet, then mix a wash of a pale red clay color and paint the entire field, working around the wood and patches of grass. Let the wash dry. Give the wood basic light colors, and fill the grass areas with bright yellow-green. With a second wash of slightly deeper value, go over the field leaving areas of the first wash showing to form clumps of earth.

STEP 2

Paint a third wash of still deeper value in the field above the lower board, again leaving some areas exposed, increasing the effect of trodden soil. In the foreground, accent the clumps of earth and grass with light shadow. Indicate the cow's shadow across the field, which gives the feel of solidity to the earth.

STEP 3

In the upper field, deepen values in some areas, add shadows throughout, and accent with extreme darks to increase the feeling of light and dimension. Brush more texture into the foreground, and shadow the grass. Darken the shadow that falls across the field, but retain the inner light. Amplify the feeling of light by darkening the shadow's edge on the wood.

Feathers

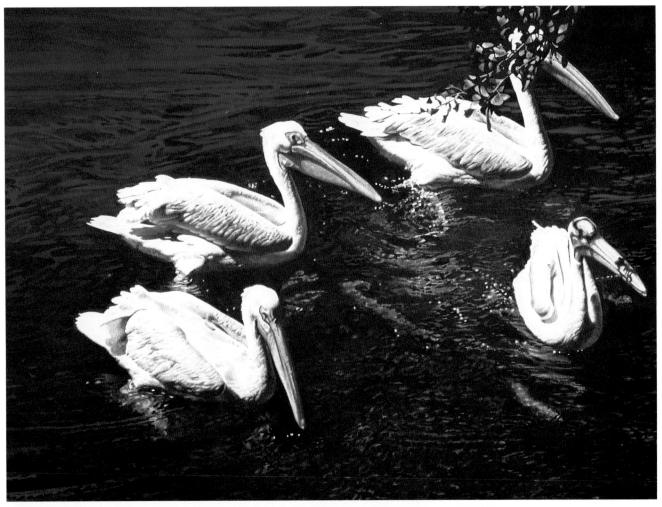

PELICANS
17" × 23"

Form, texture, dramatic light. Those are the things I saw through the lens of my camera when I photographed this scene at the zoo. Where else would I find pelicans in Philadelphia? The brilliance of the birds' down contrasted highly by the deep blue of the water captured my imagination, and I was fortunate to have a group of birds float into the composition, which made it much more interesting but more time consuming to paint. I never thought of them as graceful birds, but their beauty is evident.

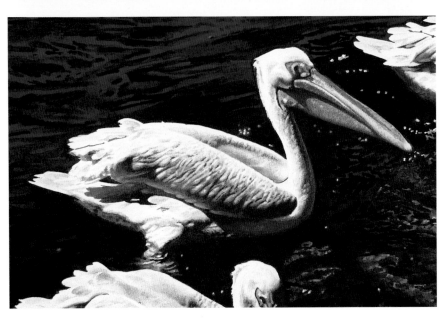

Detail of a Pelican

16

STEP 1

Establish the form and bulk of the bird by painting the pale
colors of the down's shadows and those that help shape
the graceful neck and left wing. Hold the clean white of your
paper for highlights throughout the painting. Put in first
colors of the beak then additional color on the neck. Paint
intermediate shadows on the right wing to further its form.
Define this wing with definite shadows on the bottom. As
the body nears the water, paint various colors that are
caused by light reflecting off the water. Put in the muscle
shadows on the thigh. At this point, you can outline the
bird with the dark background color to establish its contours
and value relationships. For the full-size painting, bring
each bird to this stage, then paint the entire background with
a 1-inch flat brush.

STEP 2

Develop the body further with deeper shadows, paying attention to the reflected light that is invaluable to form. Add color and texture to the beak, and begin establishing the jowl and the bulbous flesh around the eye.

STEP 3

With a no. 2 brush, add color and texture to the down, putting in shadows that help raise sections of feathers and detail their formation. Tone down the reflected light of the right wing and intensify the adjacent shadow, which increases the feeling of form. Give the neck the same treatment. Finish detailing the eye and its surrounding area, and accentuate the shadow on the jowl. Add texture to the beak, and gently shade its bottom for form. Paint the unusual shadow on the beak, and accent the small growths near the neck.

Morning Clouds

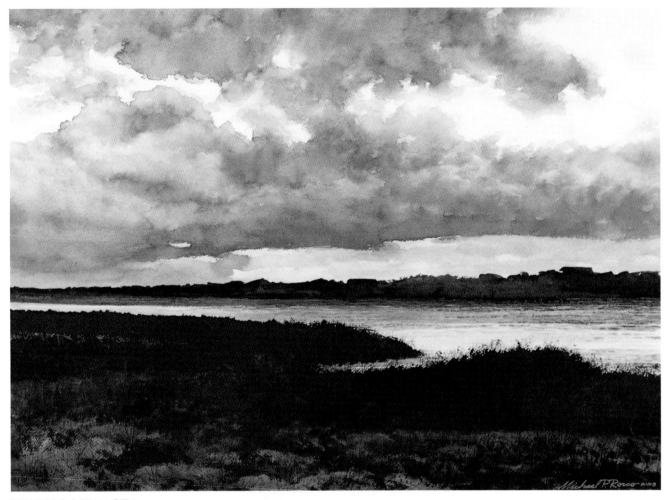

TOWARDS OCEAN CITY
17″ × 23″

Early one summer morning as I was leaving the shore, the sun was coming over the horizon causing an exciting effect in the sky that I did not want to miss. Cloud formations, even though captured by a camera, are forever changing. Each time I viewed this scene, I saw different movement and color. One thing that is constant is the clouds' softness. No matter how heavy or dark they may appear, they are still lighter than air, and painting them should reflect this quality.

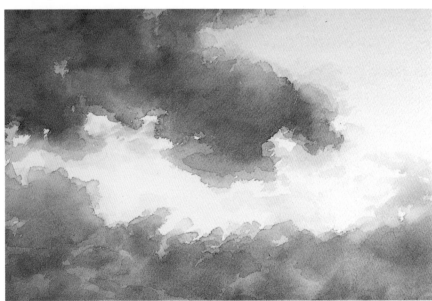

Detail of Morning Clouds

20

STEP 1

Mix enough of the two washes you need for the blend of the sky, then wet the stretched watercolor sheet completely with clean water. Apply the light color using a 1-inch flat brush and horizontal strokes, going from edge to edge covering the entire sheet in an even tone. Now reverse the position of your board, and while the first wash is still fresh, apply the second color, starting wherever the blend calls for. Still using long horizontal strokes, bring the color, getting deeper in density, to the bottom of the paper. Lay it on a flat surface to dry.

STEP 2

Lightly draw the cloud shapes onto the blend. Paint the pale, wispy clouds wherever they occur. Then mix several colors on your palette, and beginning on one end, blend the colors in wet and progress across the paper, overlaying colors, building formations, softening edges but always keeping the color moving. You don't have to limit yourself to the premixed colors. Use whatever colors are necessary until you achieve the effect.

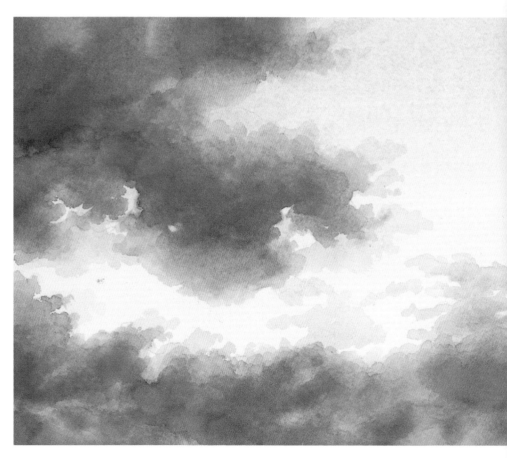

Stone

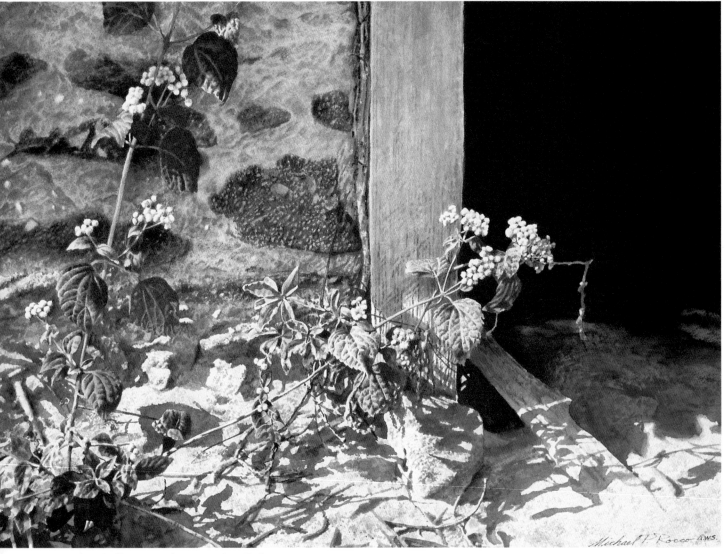

LATE SPRING
18" × 23"

This challenging subject was handled with proper planning and a simplified procedure. First I laid in the sandy earth tones, painting around all the stems and leaves. Next, the warm gray of the stone wall, followed by the color of the wood beam. I then painted the shadows on the ground and finally the extreme dark of the open doorway. In this manner, I filled the sheet with patterns, color and values and established the drama I wanted without getting into too many details.

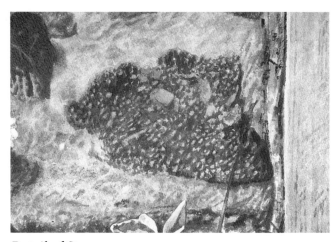

Detail of Stone

STEP 1

Paint the mortar around the stone, adding color changes while the area is still damp and cleaning away some color where light is hitting protrusions. This particular stone contains numerous shapes of different color. Cover other areas with pale washes, then soften edges at the top of the stone by scrubbing away color.

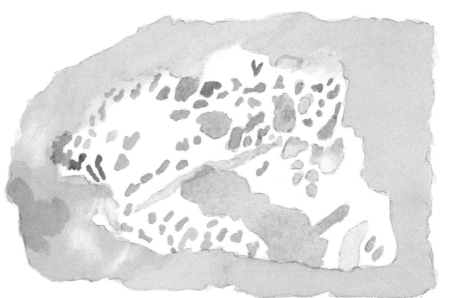

STEP 2

Paint around all the color spots with second colors, leaving specks of clear paper for highlights, deepening areas that are in shadow, until you cover the entire stone. You can gain highlights from the first pale blue wash by painting over this area in a deeper tone but leaving spots of the wash showing. Drybrush texture and shadows into the mortar.

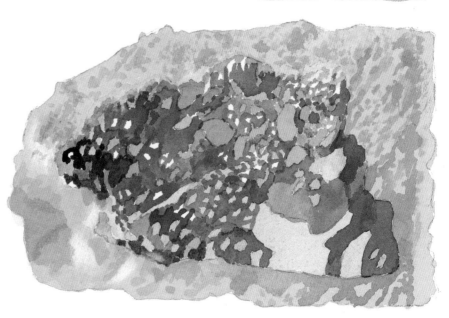

STEP 3

Continue to add color to the stone, forming ridges and highlights, painting definite shadows. Tone down the original color shapes by shading them to become part of the stone. Deepen washes and complete them. Add further dry-brush texture and shadows to accent the irregular surface of the mortar.

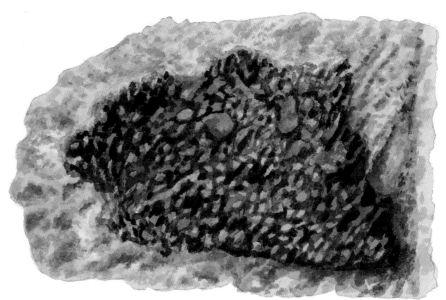

Tall Grass

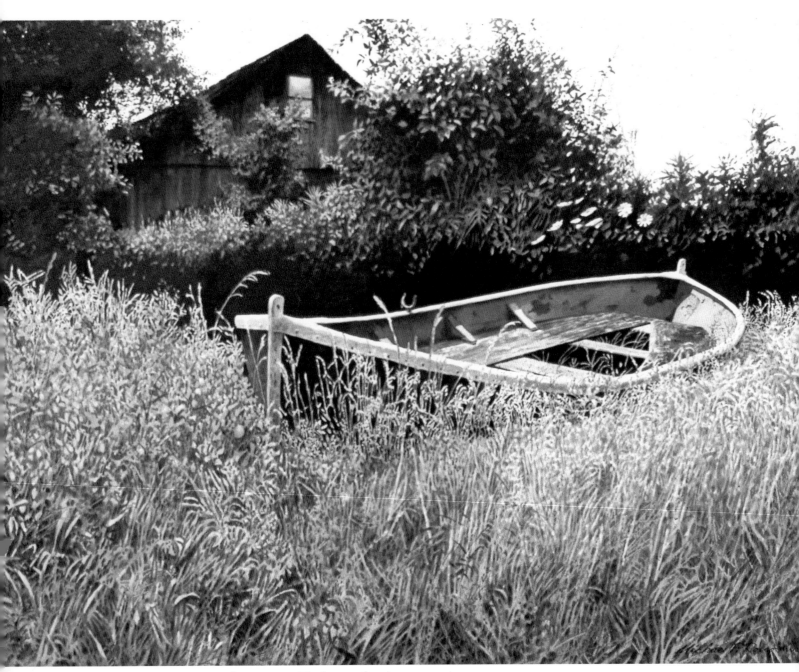

This painting is a composite of two scenes. The boat and foreground, with its overgrowth of grass and weeds, are from one transparency; however, its background was flat and uninteresting. I made a thumbnail sketch of my proposed composition then searched my slide file until I found something suitable for the background. This is the advantage of having a reference file. It saves time; it recalls certain inspirations; and new excitement can be found in subjects that might have been overlooked.

ABANDONED BOAT
17" × 23"

Detail of Tall Grass

STEP 1

Draw a minimal amount of detail in the foreground, namely the tall grasses, general shadow areas, and the prow of the boat. Everything else can be handled with brush and paint. Begin by painting freely the pale yellows throughout, and follow this with the yellow-greens. To these, add patches of yellow ochres and pale olives, forming shapes within the first washes. With a deeper olive, paint shadow areas, developing additional shapes of leaves and stems. Put in the prow of the boat giving the front board thickness.

STEP 2

To form the sunlit grass, put in a section of the boat, painting
the dark color into the pale yellow wash around the stems
and leaves. Paint the other side of the boat using the same
technique. Continue to add deeper colors, forming more
shapes. You don't need to do a tight rendering that shows
every blade of grass to capture the feel of dense, tangled
undergrowth.

STEP 3

Detail the tall grasses with shades of Yellow Ochre and Raw Umber to bring forth the sunlight. Finish the formation of the grasses by painting the dark of the boat, bringing this color down to a point where the shadows of the leaves and grass take over. Wash away some color and accentuate shadows on and under leaves to assist the feeling of light and form. Finish with the darks of the undergrowth that add to its dense look.

Trees

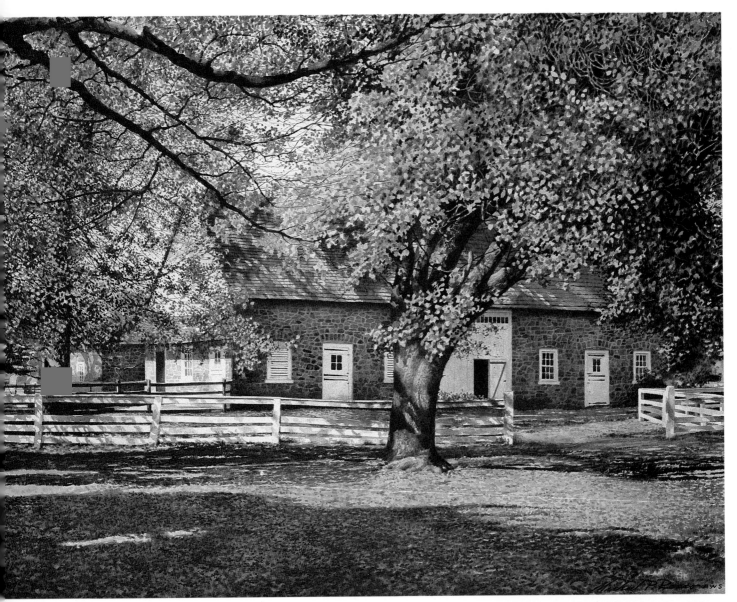

AUTUMN AT PENNSBURY, 17″ × 23″

Situated in Bucks County, Pennsylvania is Pennsbury Manor, the country home of William Penn. Completed in 1699, it included a vast estate of eight thousand acres. The house that stands there today is a re-creation of the seventeenth-century home. The beautiful fall foliage of the magnificent tree is what I wanted to capture, and that it was on a historic location made it even more interesting to me.

Detail of Trees

28

STEP 1

Draw the general shape of the tree, noting areas of the leaves and twigs that are to receive first colors. Paint the pale yellows, oranges and some bright greens of the foliage, then add the color of the twigs and the sunlit portions of the branches. Paint the trunk, and while the area is moist, blend color for soft shading. Let this all dry, then paint the background to give contours and value relationships and to establish light on the trees.

STEP 2

With various shades of yellow-green, paint most of the foliage, working around
previous colors. Once dry, add slightly deeper tones of green to the area and
into the yellows to define shapes. Then paint the shadows on the branches, again
working color to form twigs. This method of painting retains the transparency
of color. Intensify some shadows for depth, and blend more color into the trunk.

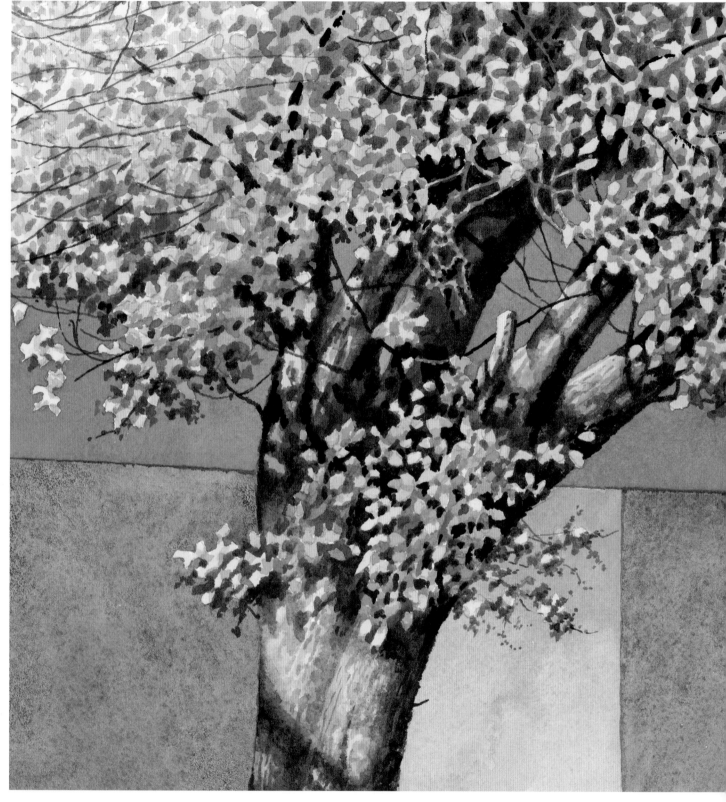

STEP 3

Paint intermediate tones in various colors throughout the foliage, defining shapes. Strengthen some yellows and oranges, adding sienna and umber for shading. Apply washes of deeper tones for depth and lastly, the dark accents. Drybrush texture into the bark, and form the branches and trunk with blends of color and shadow. Strengthen the shadow falling on the lower part of the trunk, and fade its edges softly. Paint the dark thin branches, and wash away color for additional twigs. The dark leaves painted in the background area give added depth.

31

Wildflowers

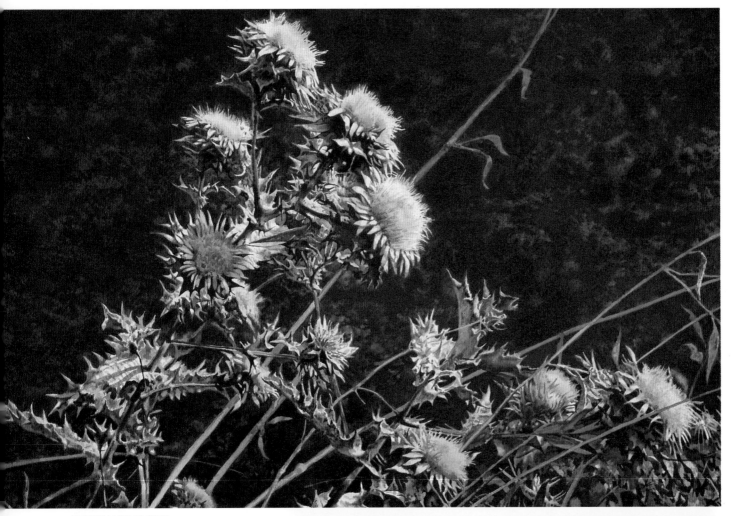

SICILIAN BRAMBLE
14″×21″

This is another challenging subject to
paint in watercolor—dramatic light
on blossoms against a dark background
and long, slender, flowing stems that
reach out from the wild underbrush.
The scene appealed to me greatly, and
while it's not a typical "flower" paint-
ing, it's the closest I come to one.

Detail of Wildflowers

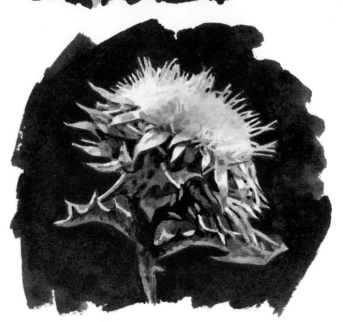

STEP 1

Paint the pale color of the blossom, and while it's still damp, blend in a slightly deeper tone. Add color to some leaves and stems. Now you want to establish contrasts. Using a no. 2 brush and dark color, outline the general shape of the blossom, then fill in the background with a larger brush. To the leaves and stem, give their finished contour.

STEP 2

Blend subtle colors into the blossom, giving softness to its cottonlike appearance. Add color to the leaves, and begin to define their form with intermediate shadows. In some areas paint splashes of color, then form shapes with darks, being aware of intertwining stems and overlapping leaves. Paint the underside of the leaves at the bottom, reflecting their curl and light.

STEP 3

Start detailing the leaves, painting in the curl of their points, adding shadows, deepening colors. Drybrush texture and accentuate the points of the leaves at the bottom, which adds intensity to the light on their edges. Extend the color at the top of the blossom, then form its filaments with background color. Add a bit more subtle shading within the blossom and it is complete.

Barn Siding

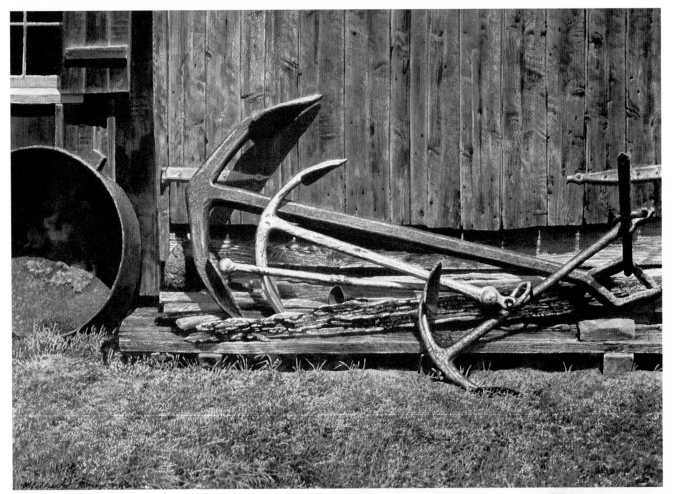

OLD ANCHORS
17" × 23"

What caught my attention about this subject was the number of huge anchors in such an unlikely place—the side of an old barn. But looking at it as a potential painting, I was impressed by the varied textures and the strong contrasts. Look at the shadow cast by the anchor onto the side of the barn. Notice its value and the amount of light it's receiving, how it stays on the wall and helps the anchor to project from it. A small but vital detail.

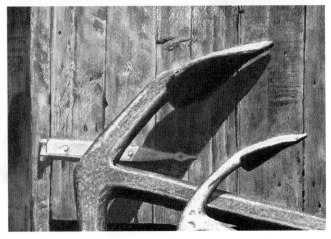

Detail of Barn Siding

STEP 1

Using a flat 1-inch brush, paint the entire side of the barn with the lightest color of the wood. Brushstrokes should be vertical, same as the siding. Once this dries, add color variations, keeping in mind where each board begins and ends. Use the broad side of a no. 8 pointed brush, dragging it on the paper for texture. The light color on the edges of the boards implies thickness.

STEP 2

Paint more color variations of the wood using the same brush technique along with some drybrush for additional texture. Light shadow lines define the boards.

STEP 3

Add final color variations and wood grain. Diagonal brushstrokes simulate saw marks. Clean off some color with water before putting in the dark holes that butt the top of the cleaned area. The roughness of the wood is accented by pinpoints of dark color. Deepen shadow lines in varying degrees.

Bright Metal

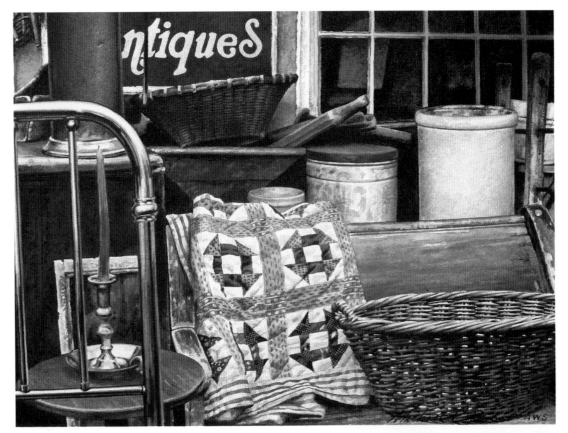

SKIPPACK ANTIQUES
10" × 13"

I never cease to find a composition to paint from the array of items in and around antique shops. However, for this painting, I eliminated a number of objects from in front of the shop window. I felt this corner would be more interesting if the eye were allowed to move to the inside of the shop. The window mullions act as a barrier to the would-be void of dark color in the upper right corner. The focus is on the quilt, but with interesting things everywhere, the viewer's eye will browse as you would in an antique shop.

Detail of Bright Metal

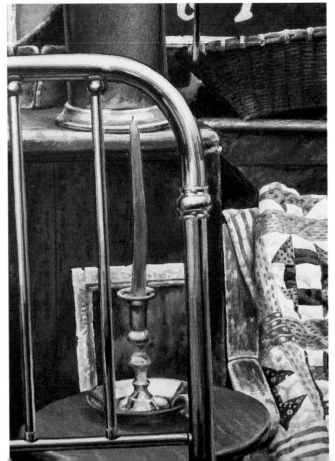

STEP 1

The secret in painting bright metal is to capture the smooth, sleek surface. Brushstrokes should emulate these qualities with evenly applied paint. First draw the image lightly on the watercolor sheet, then correct it using a T-square and triangle to ensure straight and parallel lines. Paint a pale wash of Naples Yellow on all the metal and let this dry. Add other values of colors to give shading and initial form to the rails and connectors as well as the candlestick. Straight lines can be painted with the aid of a guide for your hand and brush. The colors on the edges of the rails are reflections from other objects in the composition. Paint in the background for value relationships and to contour the metal.

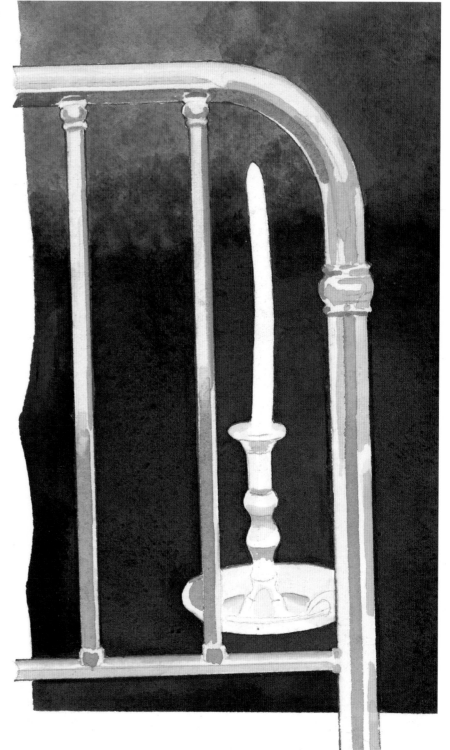

STEP 2

Further develop the tubular shapes of the brass bed by blending intermediate tones of the shadow on the top rail and adding others to the verticals and connectors. Due to the curve of the top, the dark tones have an intermittent effect. Handle the brass candlestick in the same manner, painting colors and values that reflect its form.

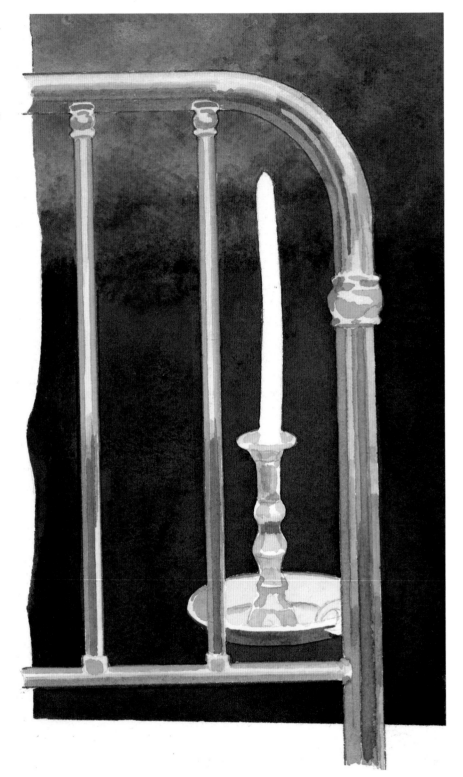

STEP 3

Tone down the reflected color under the top rail, and gradually blend deeper tones into the shadow until you gain its effect. With one exception, you can follow the same procedure for all the rails. Do not change the reflected color. Notice how the extreme dark painted along the side of reflected color accents the light and gives shape to the rails—how it makes the metal glisten. Paint the forms of all the connectors, accenting their shape and highlights with darks. On the bottom rail, the dark line is in from the edge, allowing the reflected light to add to the form. Finish the candlestick, developing its form and shapes with color and shadows, then add accents of darks for effect.

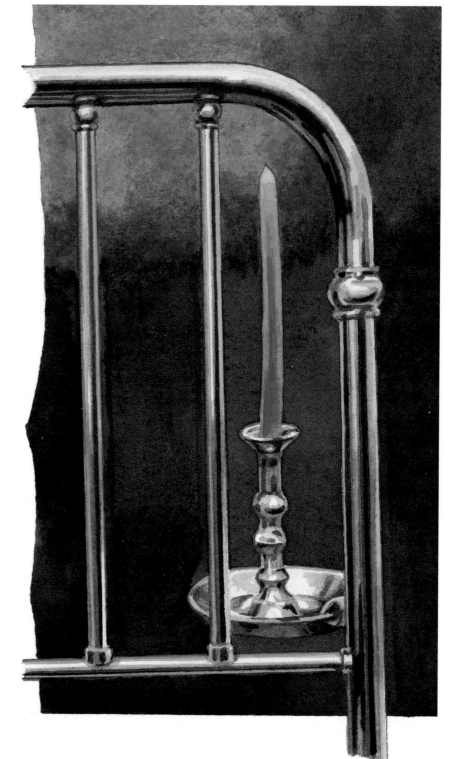

Old Brick

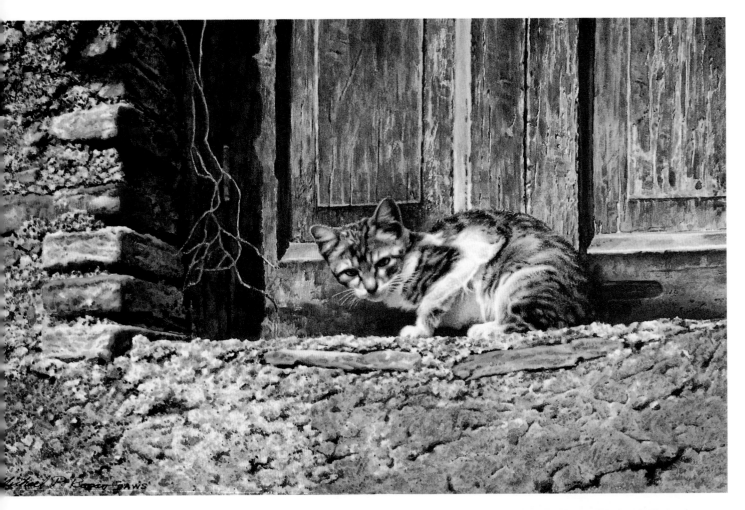

SICILIAN KITTEN
14" × 21"

It is rather odd to travel all the way to a foreign country and come home to paint a watercolor of a wary feline, but I never know when or where a composition will come about. The kitten was startled upon seeing me but lingered long enough for me to photograph it. The crude outbuilding is on a farm and houses a beehive oven and a place to stomp wine grapes.

Detail of Old Brick

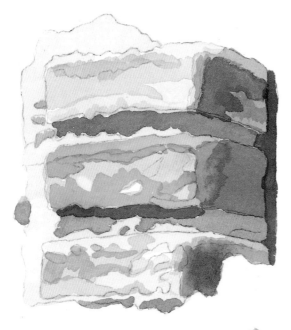

STEP 1

Paint the mortar with a wash of warm pale gray, working around the brick. Put in the varied light colors of the bricks, allowing each color to dry before painting another, to achieve hard edges. With second tones, add light shadows to the sunlit face of the brick and mortar. Establish contrasts using darks in various colors and values on the shadow sides of the brick.

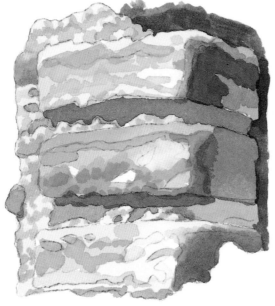

STEP 2

With intermediate tones and color variations, add texture to the mortar, developing its shadows. Due to reflected light, these shadows differ in value from those under the brick, and this relationship helps give the feeling of depth. Further develop the irregular surface of the brick with deeper tones, and paint the red brick at the top to assist the feeling of light.

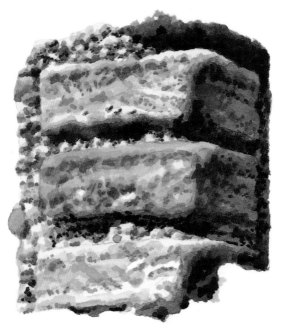

STEP 3

Accent the texture of the mortar with darks using a dry brush. Scrape away some of its color for sparkle, underlining these spots with specks of dark. Treat the face of the brick in the same manner, deepening washes, adding texture, and accenting its aged look. Strengthen shadows under the brick and the darks of the corners to add dimension and reflected light.

Old Metal

Coming upon a deserted barn brings all kinds of thoughts to mind about the people that were once here. Hard working, of course, for farm life is never an easy one. What made them leave? From the appearance of the barn, it looked like it had not been in use for some time. I pictured laughing children attempting to give their dog a bath in that old metal tub.

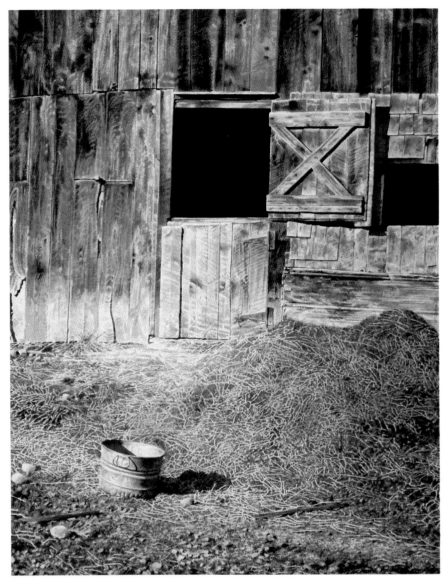

BARNYARD
23″ × 17″

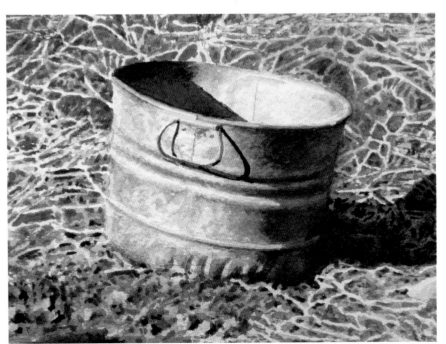

Detail of Old Metal Tub

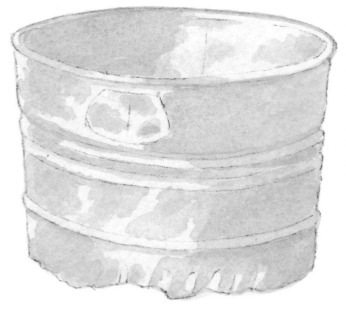

STEP 1

To obtain uniformity of value and color, paint the entire tub with a wash of pale color. Once dry, blend in a slightly deeper value, leaving sections of the first wash exposed. In this way, form the rim, handle and support ridges, and at the same time, indicate the character of the metal. With a third tone, start forming its shape.

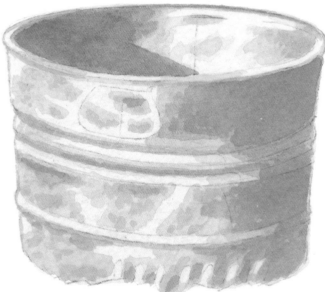

STEP 2

Shadow the inner left side and blend soft shading to the opposite side to further enhance its curve. Under the ridges, add subtle tones for a gradual change of values. There are no distinct shadows from these ridges in the sunlit area. Drybrush more texture into the metal, deepen the shadow of the outside wall, and accent the bottom ridges. Except for its various tones, galvanized metal is monochromatic, and the coloring should reflect this.

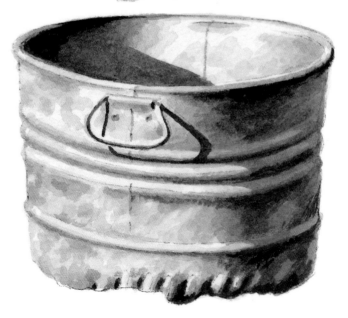

STEP 3

Paint in the discolorations on the metal. Deepen the shadow on the inner wall, but hold its quality of reflected light. As this shadow nears the upper rim, strengthen its darkness; this intensifies the feeling of light and also accents the form. Blend additional color into and deepen the shadow of the outside wall. Detail the handle and add its dramatic shadow, which gives the feeling of space between the handle and tub wall. Deepen color under the ridges to accentuate them as well as the shadows of the bottom ridges. Finish by putting in the rivets and seam lines.

Painted Wood

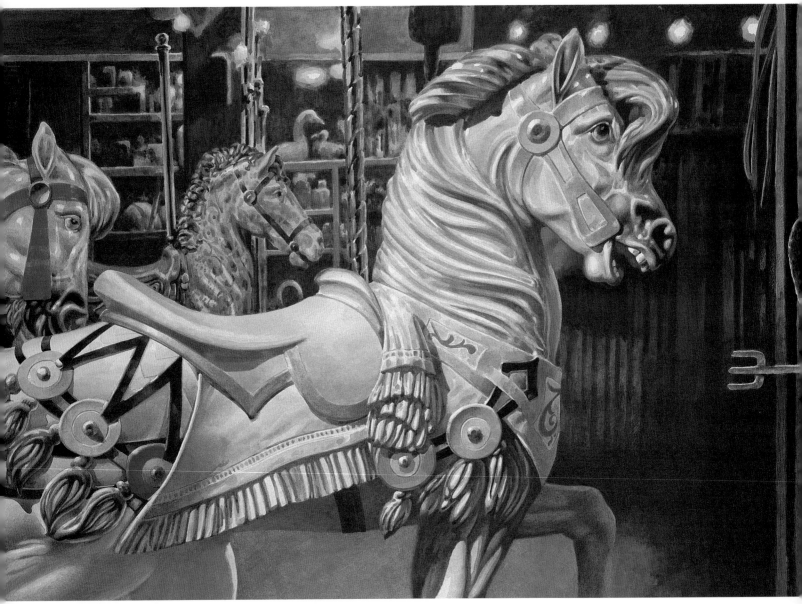

This scene was photographed at night through the display window of a carousel shop. The shop was closed, and there was no sign of human activity within. Yet the carousel horses seemed eager to go on their circular journey at the sound of the bell, galloping slowly up and down to music pumped from a calliope. They are beautiful works of art and bring enjoyment to everyone. I had always passed by this shop during the day, and while I was impressed by the horses, the scene did not strike a chord until I viewed it at night.

THE CAROUSEL SHOP
21″ × 29″

44

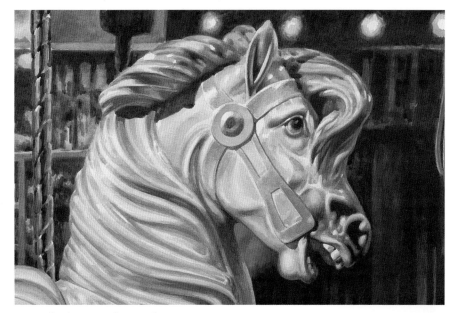

Detail of Painted Wooden
Carousel Horse

STEP 1

In painting a subject such as this, one
that has a glossy finish, it is important
to retain highlights but without over-
doing their effect. First make a very
detailed drawing of the horse on tracing
paper, then transfer only basic lines to
your watercolor sheet initially. Paint
the overall color, leaving highlights
and decorations clean. Once that is dry,
add light shadows and fill some of the
decorations with color. Put in the dark
background to establish contrasts.

STEP 2

Tape your tracing paper drawing in proper position to your watercolor sheet, and transfer additional details to the painting. Using an intermediate tone, paint the shadows of the carved mane with sweeping brushstrokes. This technique is essential to gain the smooth surface of the horse. Put in light shadows to develop the form of the head and flowing hair. Strengthen some shadows, adding to the feeling of dimension. Put in first colors of the mouth and nose.

STEP 3

Return the tracing paper drawing to position, and transfer final details. Paint slashes of color along with accents of dark, which add to the appearance of a glossy surface. Blend subtle shading into the collar forming it to the horse's chest, then work the ornamental button to its concave shape. Accenting the gold hobnails adds to the dimensional feel. Detail the remaining decorations with the same careful attention. Finish the head with gradually deeper shading, then amplify the effect with darks. The careful use of highlights and the way you apply the paint are significant to the success of this painting.

Rusted Metal

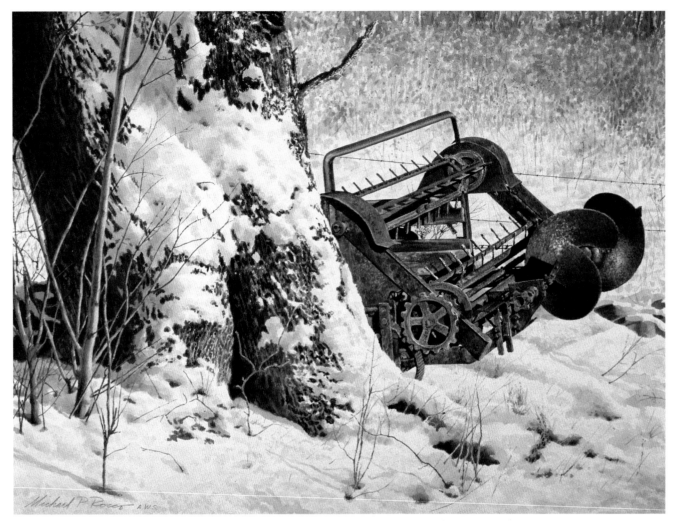

FARM RELIC
16" × 21"

This is another painting achieved from different transparencies. I wanted to paint the handsome snow-covered tree trunk but felt it needed something more to tell a story and be of greater interest. Fortunately some distance away in the field, I found the discarded tiller. Its gracefully formed blades, worn and encrusted, were full of appealing earthy colors. The tiller made a good foil against the snow and tree, and I relish the contrasts of texture within the painting.

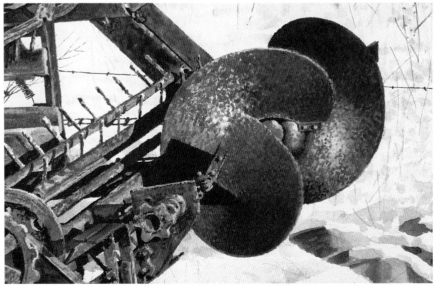

Detail of Rusted Metal Tiller

48

STEP 1

To gain the look and texture of rust, paint patches of light color throughout, noting bends and planes of metal angles, cylindrical rods, and curvature of the blades. Follow this with intermediate colors to further structure the various shapes and begin the texture. Paint the dark brown of the uppermost blade to establish a space relation with the middle blade. Put in the strong shadows to help clarify the mechanism and attain brilliance.

STEP 2

Start painting the texture of the crusted metal by overlaying colors and working into the original areas. Use the point of a no. 4 round brush to spot in colors in a methodical pattern. On the foreground metal plate, put in the light on its edge that sets it apart from the shadow of the blades. Note the number of colors used here. Generally one thinks of rust as reddish brown, but it takes on a variety of colors depending on the light.

STEP 3

Continue to texture the metal in the same manner, bringing values down and developing the beautiful contours of the blades. Be careful not to lose the sparkle of sunlight on the metal. Finish the chain gear in a similar manner, putting in highlights on edges, shaping with intermediate color, and accenting with shadows for depth. Don't overlook details such as rivets and prongs. Specks of dark color pronounce their appearance.

Flowing Water

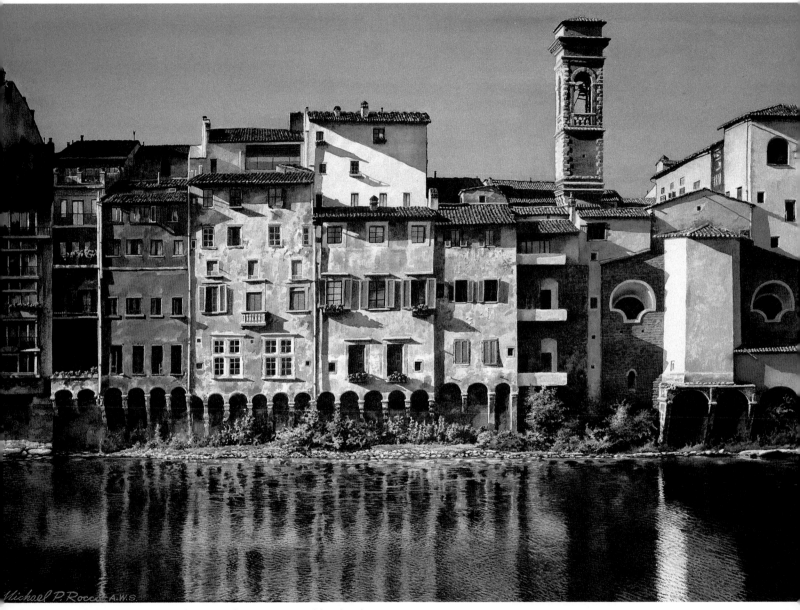

Whenever we visit Italy, I am always impressed by the clarity of light and the strength of shadows. The composition of the shadows themselves are interesting due to the architecture: staggered houses, balconies with iron railings, shutters, arches, tiled roofs. This scene intrigued me for that reason: The contrast of the facades in a late afternoon sun with shadows all over, balanced by a darkened river illuminated only by reflections.

ALONG THE ARNO RIVER
21″ × 29″

Detail of River Reflections

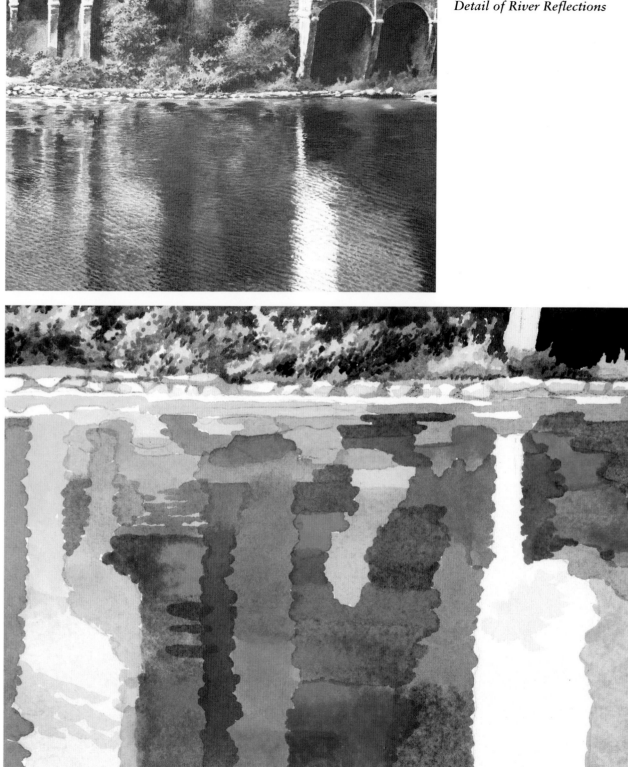

STEP 1

To paint the reflections in the river correctly, work on the background first to establish basic structure, color and values. The positions of reflections have to be correct. Begin the river by painting the lightest colors using horizontal strokes in a downward direction, resulting in ragged edges. Now working in a section at a time, add color patches across the paper to achieve an overall abstract pattern. The horizontal reflection of rocks along the riverbank can be left clean for now.

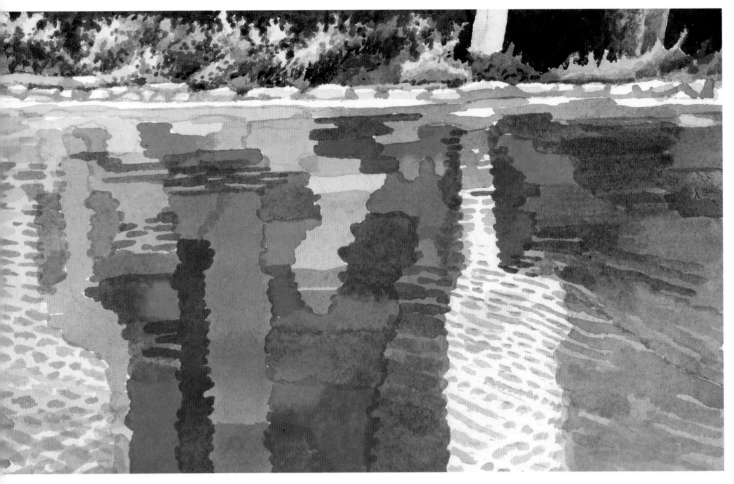

STEP 2

Now begin developing the feel and flow of the water. With deeper tones, paint ripples into lighter areas. In other areas, lay an intermediate wash over existing color, leaving highlights as ripples. You can see this clearly in the lower right corner of the painting. Notice the flow of ripples coinciding with the two areas.

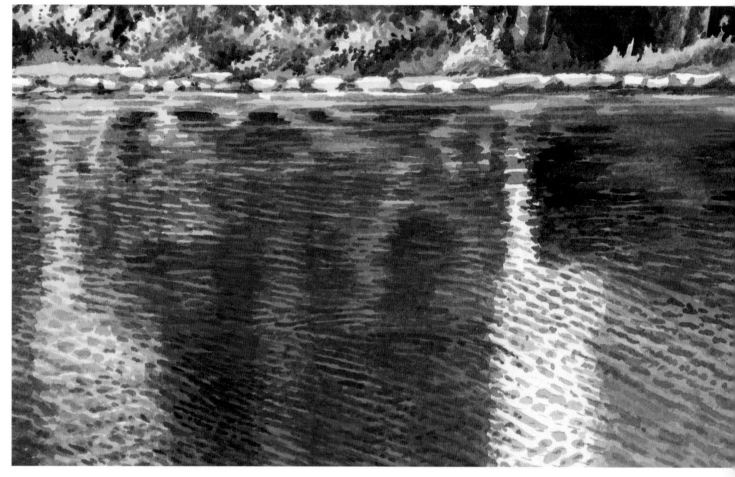

STEP 3

Continue working sections at a time in a random order, adding colors in general to give the water its silky smooth quality yet capture the movement. Blend adjacent areas with intermediate colors, and glaze them with dark accents, following the flow of the ripples. There are crosscurrents in the foreground that add considerably to the motion. The flow changes in the central region, then runs parallel to the river bank. Make your brushstrokes reflect this movement. Wash away small areas of color for sparkle, and accent lights with darks, which add to the luminous quality of the water. Finish with the reflection of the rocks along the bank.

Moonlit Snow

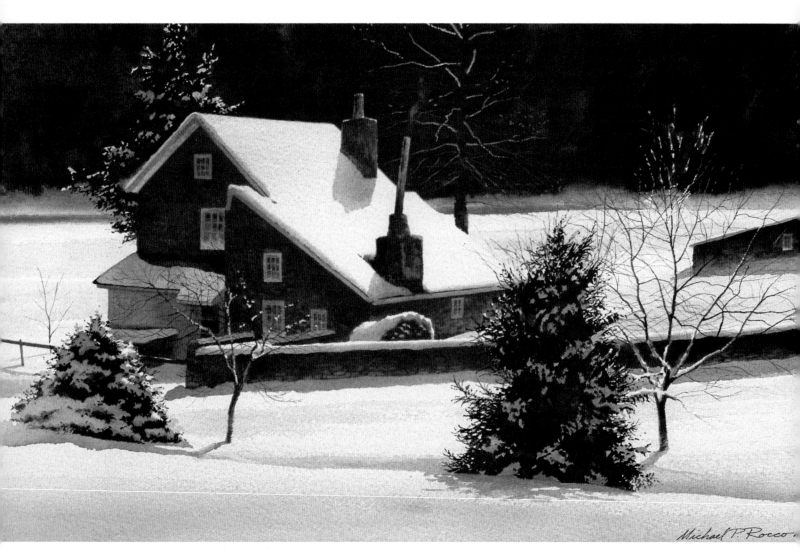

FEBRUARY NIGHT, 14" × 21"

A winter's night with a full blanket of snow covering the countryside. The moon spreading its luminous glow over the snow. Not a sound breaks the silence. The solitude gives a feeling of reverence. The house, situated in the Brandywine Valley, is one I have photographed in all seasons but always during the day. But painting it as a night scene gave an entirely different and dramatic mood to an ordinary subject.

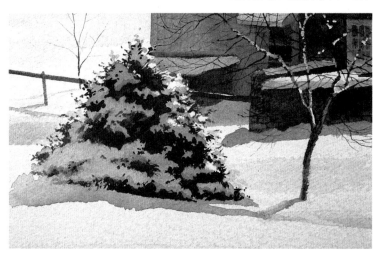

Detail of Snow-laden Tree

STEP 1

After applying a pale wash over the entire sheet and allowing it to dry, draw the general shapes of the composition. Blend the snowdrift shadows into the wash, then add the deeper shadows of the snow on the tree and ground plus those of the background. (Don't overwork them and lose their freshness.) Wash away some color from the tree and the top of the wall for highlighted areas of snow.

STEP 2

Work on the background to establish values and space relationships. First put in the side of the house, then the stone wall, whose value gets lighter as it nears the snow. The reflected light adds greatly to the mood of this painting. Try to paint around the branches of the tree on the right.

STEP 3

Now work on the big tree, deepening shadows in the mounds of snow on the branches to give them form. Put in the dark color of the tree, which adds contrast and brilliance to the moonlit surroundings. However, paint this dark with varying values to avoid a flat look. Where the snow touches the tree, soften some edges with subtle color changes. Add details to the stone wall, paint the tree on the right and the fence and the bare tree on the left. With a stencil knife, scratch away color to highlight the fence.

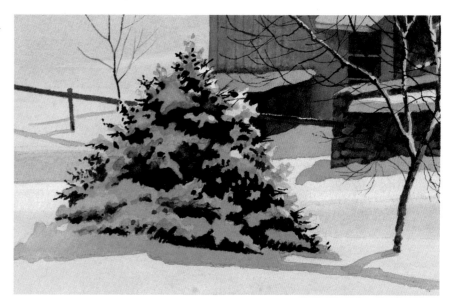

People in Sunlight

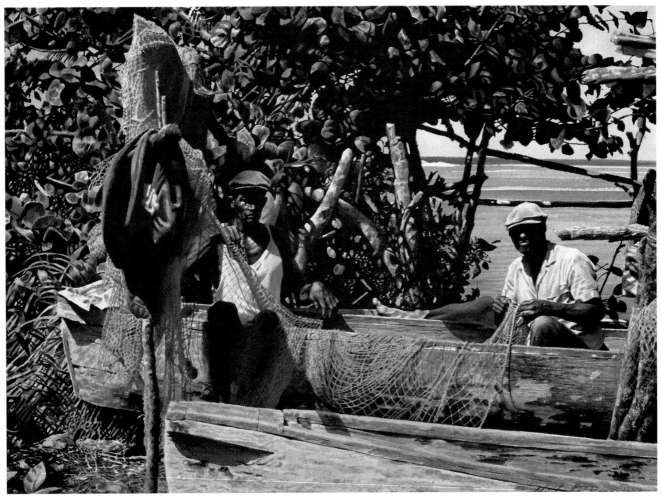

MENDING THE NETS, 18″×23″

I came upon this scene while on a short vacation to Jamaica. Walking through areas not meant for tourists and visiting markets, back streets, and isolated beaches with twisted tropical trees, I came upon these fishermen in a small village. With their permission, I photographed them, thanked them and continued my exploration. The experience made an impression, and I have painted several pieces from that excursion.

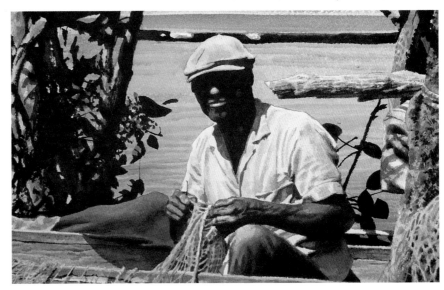

Detail of Sunlit Man

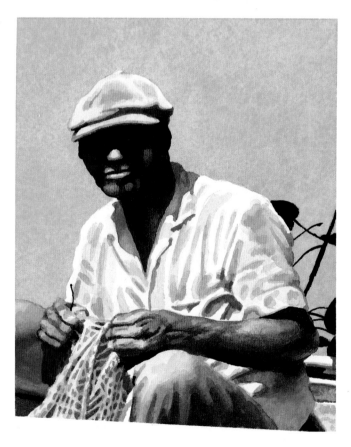

STEP 1

Put in a simplified background first by premixing ample color, then outlining a portion of the contour using a no. 2 brush, filling the area with a larger brush as you go. In this way, you keep the color flowing and do not allow any section to dry, thus finishing with an even wash. After this dries, paint pale washes in the shirt, cap and trousers, then add deeper color in the shirt for shadows and reflected light.

STEP 2

Put in the light shadows of creases in the shirt and cap and folds in the net. Blend color into the trousers, keeping the faded look at the knee. Begin constructing the head by painting the prominent highlights of the features, adding color to the cheeks, chin and neck. Paint light tones in the hands and forearm, blending in indications of shadow.

STEP 3

Develop the shirt's creases with deeper values, and put in the shadow near the neck. (Note the reflected light.) Paint the shadow on the head and neck with a dark wash, working around previously painted areas, then blend this color softly into the highlights with intermediate colors, using the point of a no. 2 brush. Model the form of the hands and forearm using colors to capture the glistening skin. Accentuate veins and muscles to indicate this man's laborious life.

Reflections

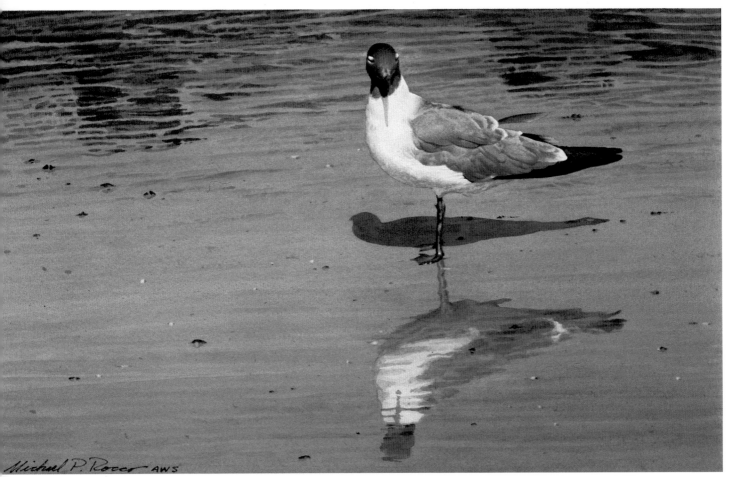

ON THE BEACH, 11" × 17"

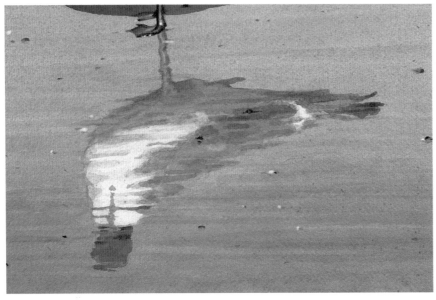

Detail of Bird's Reflection

What interested me about this composition was the almost mirrorlike reflection of the bird. When painting reflections, remember, you are not seeing an exact, flopped version of the object. Note that the breast of the bird is generally in sunlight, whereas in the reflection, you see more of the underside that is in shadow. The reflections in the upper portion of the painting are also important: Not only do they indicate there is something beyond but they also stop the eye from traveling off the top of the painting.

STEP 1

If you wish, use a masking fluid to keep a section of the paper clean when you paint your wash. Use two coats of the liquid, allowing drying time between coats, to assure good coverage. Mix an ample amount of wash color, and test a sample on scrap paper. Wet the stretched paper with clean water, let it soak for a minute, then apply the wash with a 1-inch flat brush and let it dry.

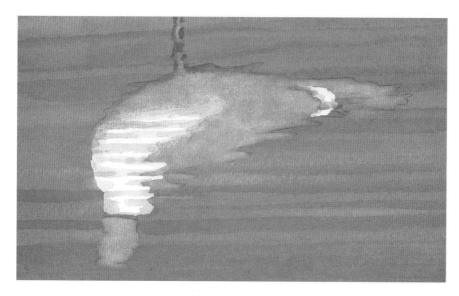

STEP 2

To the wash, blend horizontal ripples into the watery beach, then clean away some of the wash for ripple high-lights. If you are satisfied with the effect, remove the masking fluid with a rubber cement pickup. Using clean water, lighten color to form darker areas of the gull's reflection. Scrub away some of the hard edges caused by the mask until they fade into the clean area. Then add ripples in a pale color. Paint the reflection of the gull's leg and some feathers.

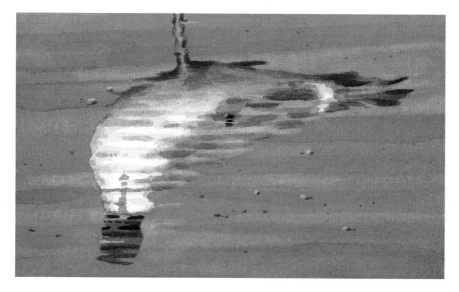

STEP 3

Clean more color from the beach to in-crease its wet feel. Blend changes of color and deeper tones into the reflec-tion to give it form. Paint the head with the same wet feeling, and accent ripples with splashes of darks. Clean away spots on the beach for pebbles, then shadow them. These give solidity to the beach.

Snow Shadows

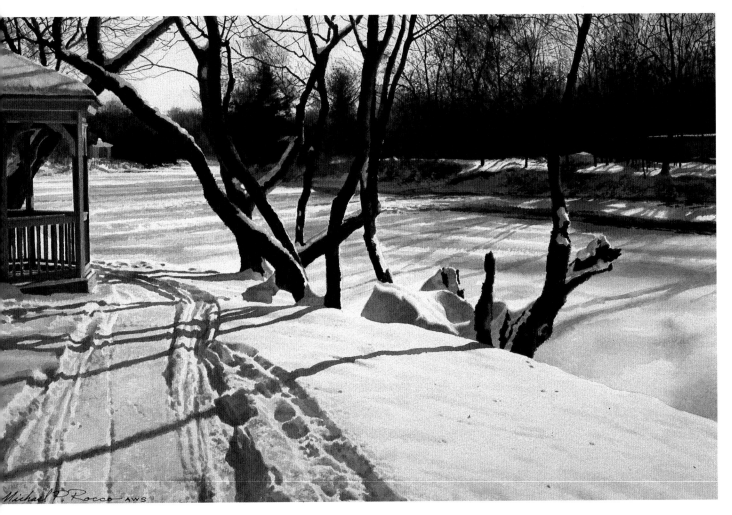

SNOW TRACKS, 14" × 21"

Many conditions affect the appearance of snow. It is not always pure white. Snow is different colors depending on the time of day, the weather, whether it's soft snow or snow that has been glazed by the cold. This scene attracted me for several reasons: the brilliance of the snow, the frozen creek, the long shadows from a late afternoon sun, and the stark simplicity of a contrasting background. I had to get it on paper—quickly!

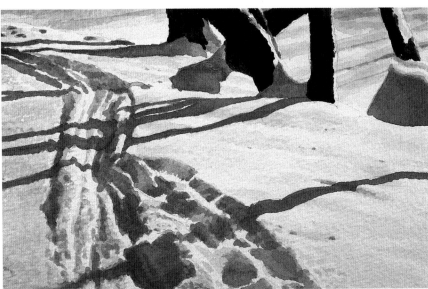

Detail of Snow Shadows

STEP 1

Start with a pale yellow wash over the foreground snow up to the snow track area. Follow this with a tint of violet to paint the frozen creek. Leave the trees clean to use the white of the paper as specks of sparkling snow. Next add the snow tracks using variations of values in this pale color to obtain the feeling of light within the shadows. Paint all these colors on a dry surface, allowing each to dry separately.

STEP 2

Paint a deeper tone of yellow onto the snow where drifts occur. To form the mounds in the tracks, add intermediate tones in a spotty manner. Paint the pale shadows that fall across the creek. To establish brilliance by contrast, put in the shadows on the mounds at the base of the trees.

STEP 3

Deepen and accent shadows of the irregular snow in the tracks, being careful not to lose the effect of reflected light. Add the long shadows falling across the foreground, following the contours of the drifts and ridges. Here again, values and colors change, so absorb some of the wash for reflected light. Soften the top edge of the shadows on the large mounds, and add shadow to the snow on the trees. Painting the darks of the trees amplifies the sunlit brilliance of the composition.

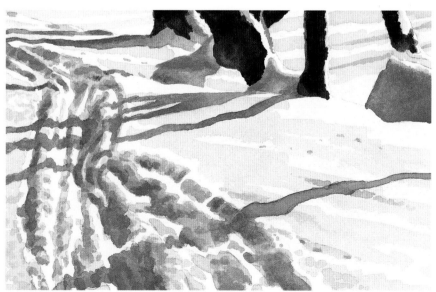

STILL-LIFE TEXTURES

Dark Glass

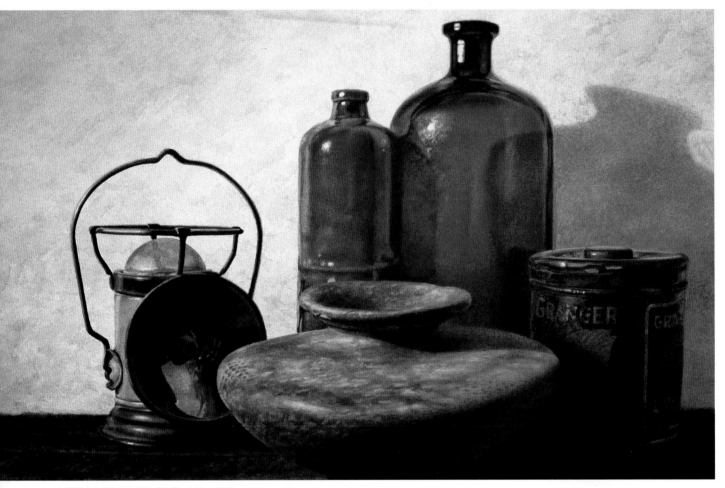

STILL LIFE WITH LAMP, 11″ × 17″

This is a still life put together in my studio with odds and ends from our "yard sale" collection. The thing to remember in painting glass is that most of it has an extremely smooth surface, and your color washes should reflect this. Equally important is to obtain the transparency or translucency of the object. In this painting, the light passing through the glass, producing a warm glow within the shadow, helps to project that feeling.

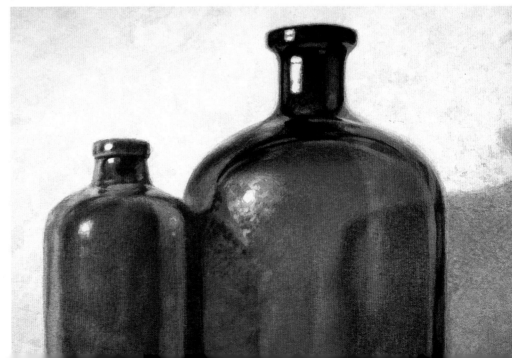

Detail of Dark Glass Jug

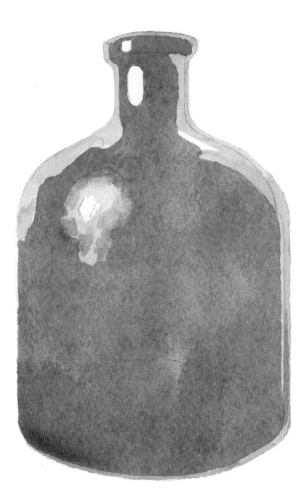

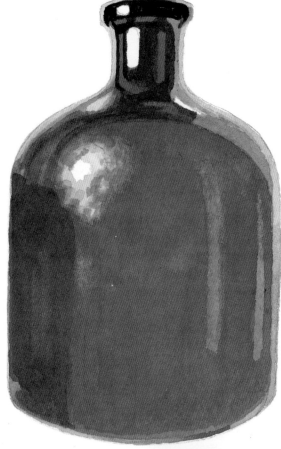

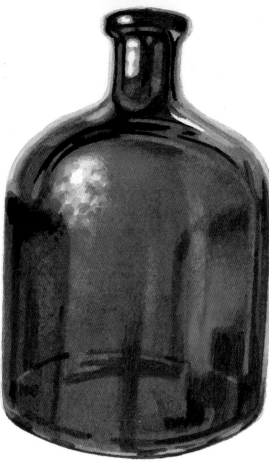

STEP 1

Start by painting the color along the edges and the glare of light on the body of the flask. Once that dries, paint an overall even base color, leaving the extreme highlights on the flange and neck. This base color is determined by the secondary highlights on the body of the flask. Allow this wash to dry.

STEP 2

Apply another wash to deepen color, leaving some of the base color showing on the right portion of the flask. Soften the edges with clean water, and blend carefully for smoothness. Add deep color on the flange, neck and top of the body to start feeling its form, and add the shadow on the left.

STEP 3

With a small pointed brush, "noodle" the form of the flask using very short strokes. Add deeper accents to obtain the roundness of the shape. Paint the base, paying attention to its inner contour and cleaning off some color for highlights. To give the glass transparency, clean off some more areas of paint with water and brush. The shadow that can be seen through the glass on the right amplifies the feeling of transparency.

Draped Cloth

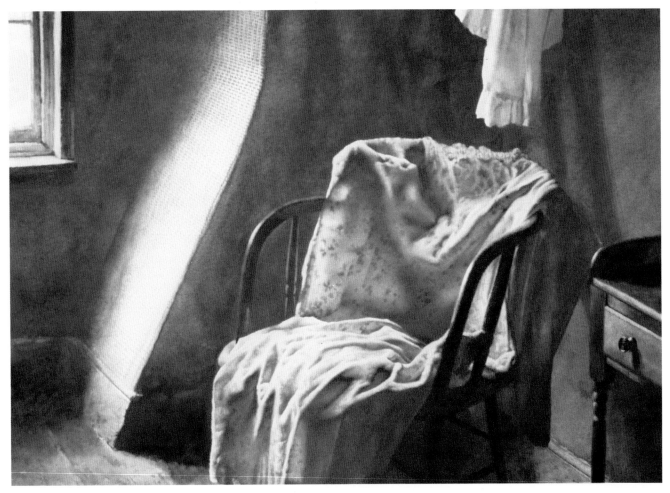

THE DRESS, 17" × 23"

This is a scene from a house in the historic area of Gettysburg, Pennsylvania. The story is told that Jenny Wade was the only civilian killed in that famous battle of the Civil War. She allegedly was making cookies at the time a stray shot came through the wood and mortally wounded her. The soft light from the window filtering into the room with its angled alcove and plain wallpaper, along with the fascinating story, compelled me to do the painting.

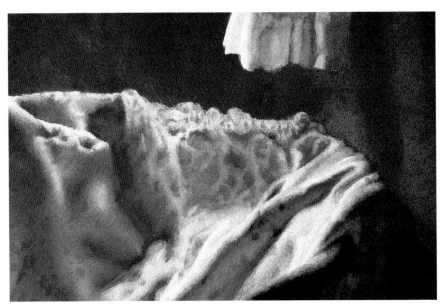

Detail of Draped Cloth

STEP 1

After drawing the image, paint a pale blue wash on the dress, and while it is still damp, drop in some color on the ruffle of the neckline. Once this is dry, put in a simple background to establish contrasts. Add a deeper tone of blue, leaving sections of your first wash exposed for highlights on the folds of the materials.

STEP 2

Put in a third tone of blue, again leaving areas of the previous washes showing. At this point it resembles a silkscreen print with its flat areas of color and hard edges, but you are establishing the formation of the folds and proper values of shadow. There are so many wrinkles to contend with that it's easier to paint in this method and blend later.

STEP 3

Now you can wash and blend. Using clean water, work the harsh edges of darker tones into the lighter color until you gain the soft roll of the folds. Deepen shadows to form definite creases, and with their proper placement, you'll achieve the reflected light on a fold. Add deeper tones to the ruffle giving it shape, then accent with darks to further the feeling of light. With varying values of color, paint the dot pattern of the cloth but not completely, for in some areas the dots are obliterated by the light.

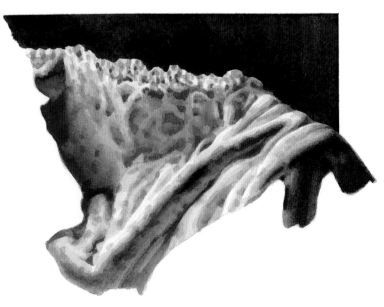

Glazed Crockery

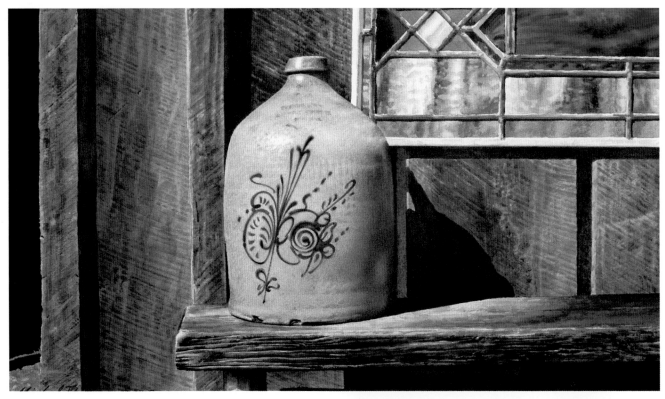

JUG AND STAINED GLASS, 12″ × 19″

My enjoyment of antiques is mostly for their aesthetic quali-
ties. I am intrigued by the interesting clutter one finds in
and around most antique shops. However, aside from a few
other artifacts, the glazed jug and the stained glass were all
that were in front of this shop. The simplicity and direct
statement of the composition, along with the textures, was
reason enough for me to paint.

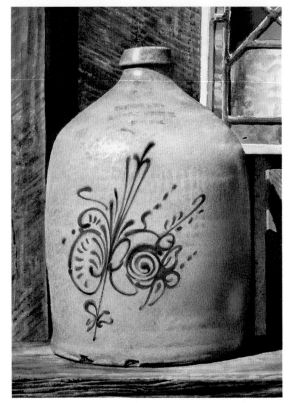

Detail of Glazed Crockery

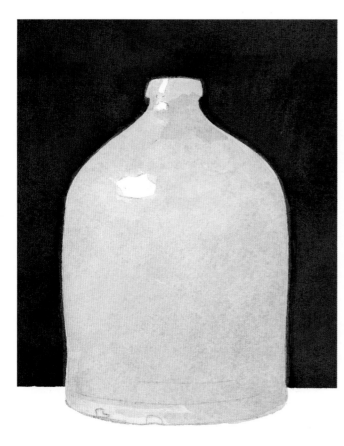

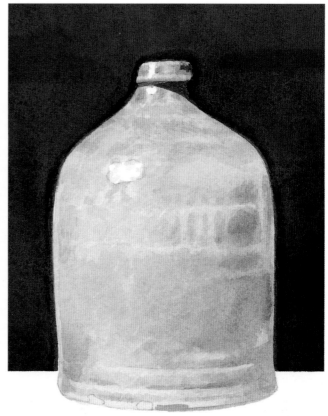

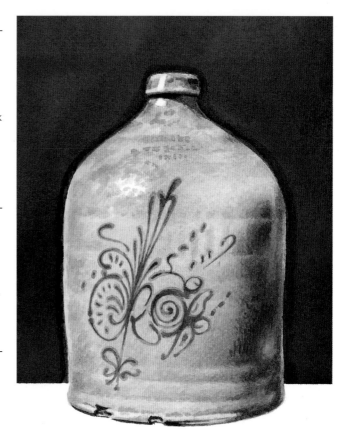

STEP 1

Besides form, the important thing to capture in earthenware is the glaze generally found on the surface. Begin by painting various tints of color, working these in a wet blend on dry paper. Keep the color flowing and fresh so no area dries, but leave the highlights clean. Once dry, put in the dark background to give the feeling of light on the jug. Add a second tone under the lip, and clean away some color from the jug's bottom, giving a highlight to that ridge.

STEP 2

Blend washes of color to develop the form and glaze of the body. Wash away more color to form ridges and valleys, accenting these with light shadow. Paint some shadows on the right, staying in from the edge, which has reflected light to give the jug its cylindrical feel. Add tones to the lip, gently turning it under, and put in the shadow on the neck.

STEP 3

With the point of a no. 2 brush, blend in colors, feeling the form as you render. Work the dark shadow with gradually deeper tones of varied color, for it too contains a great deal of reflected light. The blue design has indistinct edges. To get this effect, first paint it in a pale blue, then add deeper blue to the center of all the lines. Finish by adding the chipped notches and shadow line on the bottom.

Rope

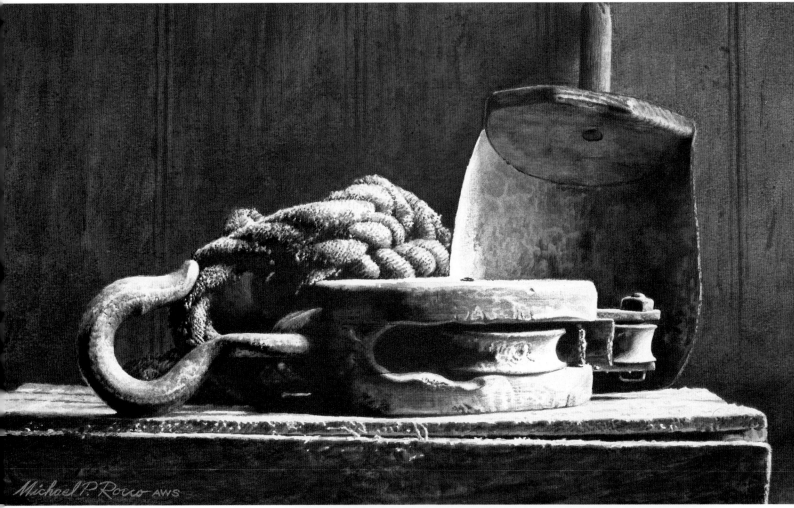

Michael P. Rocco AWS

STILL LIFE WITH SCOOP, 12″ × 18″

When we had our summer house at the seashore, one of our favorite pastimes was garage and yard sale hunting. Over the course of years, we accumulated quite a bit of odds and ends. Some of the more interesting items I used to set up still lifes and photographed them with intentions of painting them at a later date. Creating these compositions was a complete departure from my other subject matter and added something new to keep my interest at a high level. Besides, I had the actual objects to refer to if needed.

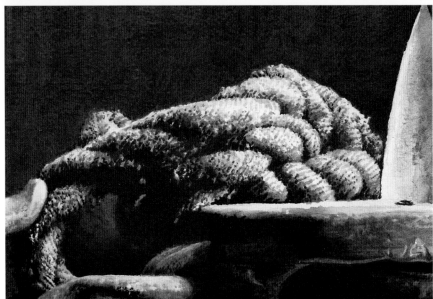

Detail of Rope

STEP 1

Mix a pale wash consisting of Naples Yellow and Yellow Ochre, and paint the rope, allowing it to dry. Then put in the background for light effect and comparison of future values. For this area, use two brushes, a no. 4 round for outlining and a 1-inch flat for filling. Starting at the rope, outline a small section, then fill immediately down to the edge of the paper, keeping the color flowing at all times.

STEP 2

Using Raw Umber, paint shading to help clarify and hold the bunched rope as a mass. Add pale washes of Payne's Gray for form and to delineate the spiraled weave of the strand. Paint deeper tones of these colors in some areas for added depth.

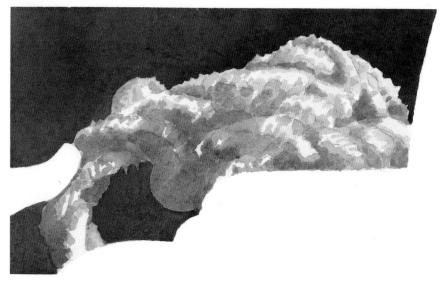

STEP 3

Now detail the weave using various values of colors. Accent the coarse fibers with specks of dark color. In some areas, where the light is strongest, the weave is lost completely. Strengthen the form of the strands with deeper tones and dark shadows, which also add to the feeling of light. Treat the shadowed area (bottom center) without any detail except for reflected light. This intense dark solidifies the mass and gives light to the background, producing a spatial relationship between the wall and rope. Wash and scrape away color to highlight coarse fibers, then accent weave lines and soften the top contour of the rope.

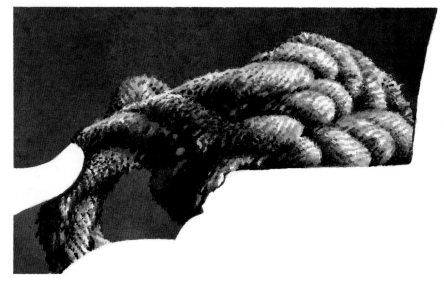

Stained Glass

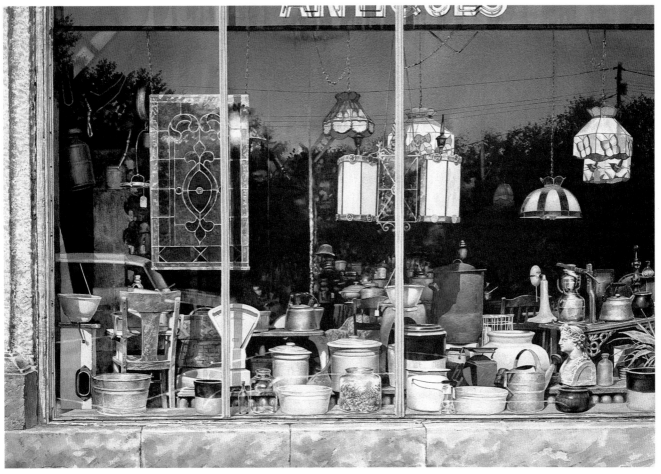

REFLECTIONS OF THE PAST, 21″×29″

For challenging subjects, this one is near the top of the list, simply for the amount of items that had to be painted. Antique shops are generally cluttered, but I knew from the excitement I felt viewing this monumental conglomeration that I would attempt to put it down on paper. Simplification of procedure was needed. I started by painting the reflected light of the window pane across the entire sheet, for this area needed a unity to its tonal quality. Then I concentrated on one section of the divided window at a time.

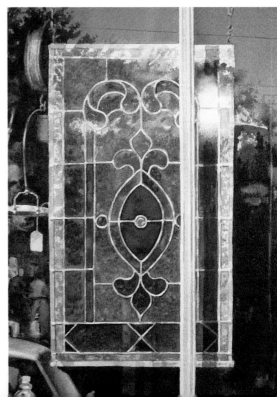

Detail of Stained Glass Panel

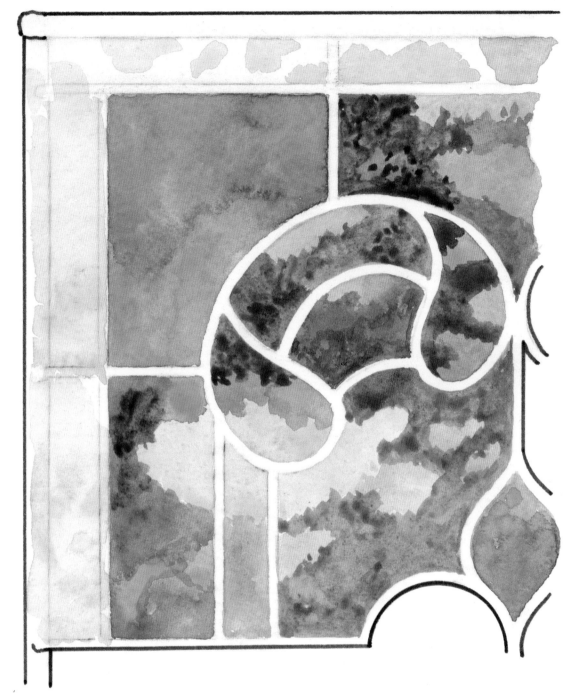

STEP 1

For this demonstration, we'll render only the top left portion
of the panel. (The dark outline is merely for definition.)
Begin by painting basic light areas in each section, then sur-
round these with appropriate colors. The darker tones are
caused by reflections of a tree on the panel. Apply some col-
ors wet-into-wet to get variations in the blend. Add deeper
tones throughout to simulate the uneven surface of the glass.

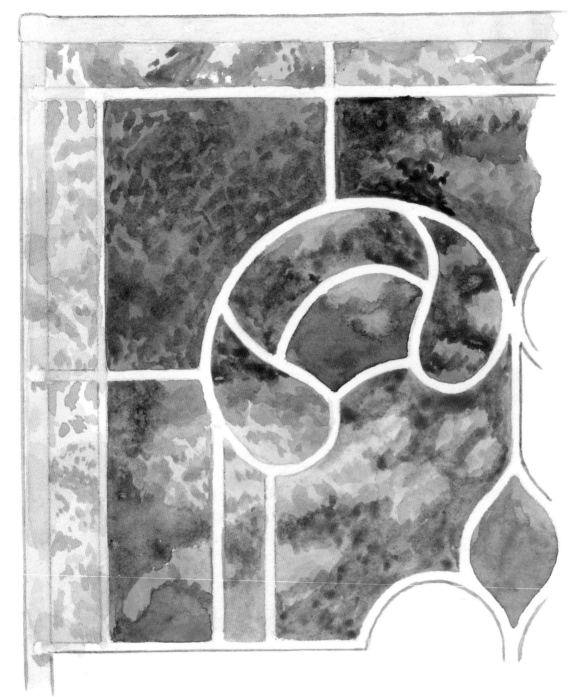

STEP 2

Continue to develop the rippled glass with additional deep tones, and carry the texture into the lighter areas. Soften harsh edges by washing away color and blending. Paint the outer frame and some of the shadows on it caused by reflections.

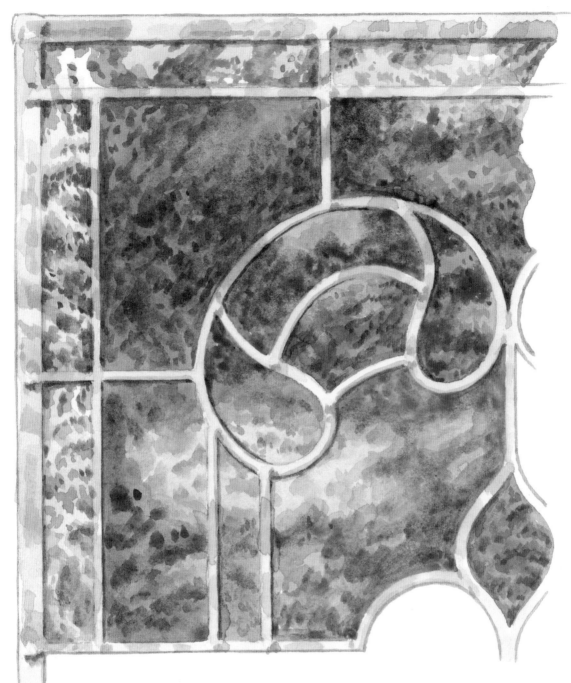

STEP 3

Finish accenting ripples in the glass using dark tones of the color used in each section. The leading of this panel has a pale green patina, which is fortunate, for the light color helps the definition. Shadows fall all over the panel, so paint these to assist the continuity of the reflections. With thin lines, accent the dimension of the leading, putting in shadows especially at soldered joints. This stained glass panel has no backlighting, and its color differs greatly from the illuminated hanging lamps (see the large finished painting on pages 4 and 5).

Wicker

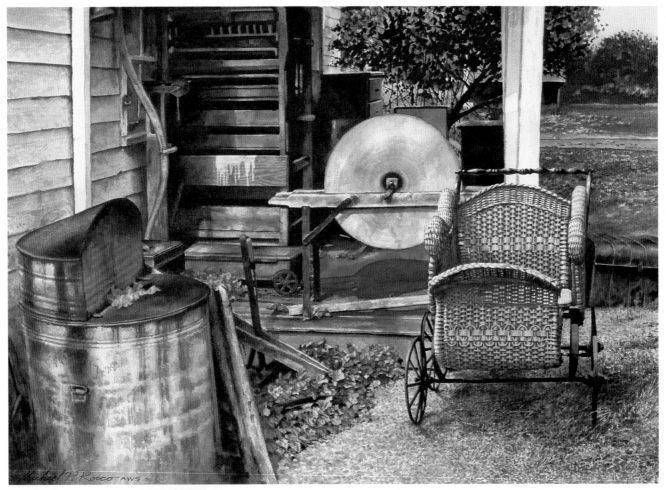

WICKER COACH
17" × 23"

In painting a subject that is complex
and seems to be a confusion of lines, I
always make a drawing on tracing
paper so that I have something to refer
to when needed. I started the painting
above by drawing the projected image
directly onto the watercolor paper, ex-
cept for the wicker coach. Here I taped
a sheet of tracing paper in position, be-
ing careful not to disturb my board, and
made a very detailed drawing of the
coach. The step-by-step demonstration
on the next few pages illustrates how
to paint a woven surface.

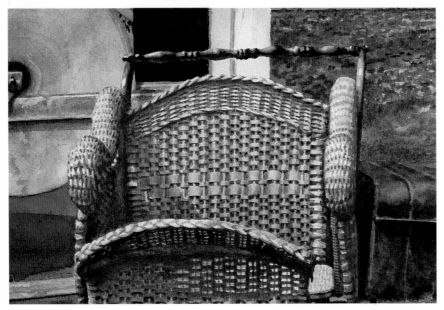

Detail of Wicker Coach

74

STEP 1

After tracing the general outline of the coach, paint its lightest color over the entire area. Once the wash is dry, tape your drawing in position and transfer certain sections onto the painting. Now add a second tone, blending where necessary, but leaving areas of your first wash showing. Paint a third tone of deeper value to start establishing form and shadow.

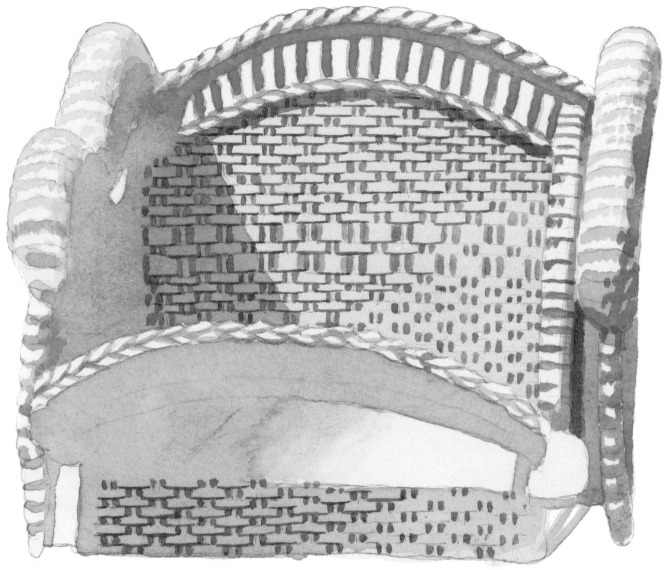

STEP 2

Strengthen some shadows and put in the cast shadow on the left as well as the one under the roping. Again, tape your drawing in position and carefully trace the weave onto the painting. You can simplify your painting procedure by putting in all the darks on each side of the vertical reeds, stopping these shadows at the top and bottom of the horizontal weave, thus giving thickness to the reeds and width to the flat strips. Next, line the bottom of all the horizontals. The tops are receiving light and do not get a shadow. Add shading to the rope weave on the back as well as the intertwined weave of the front. Paint light tones on the side tops to create a ripple effect.

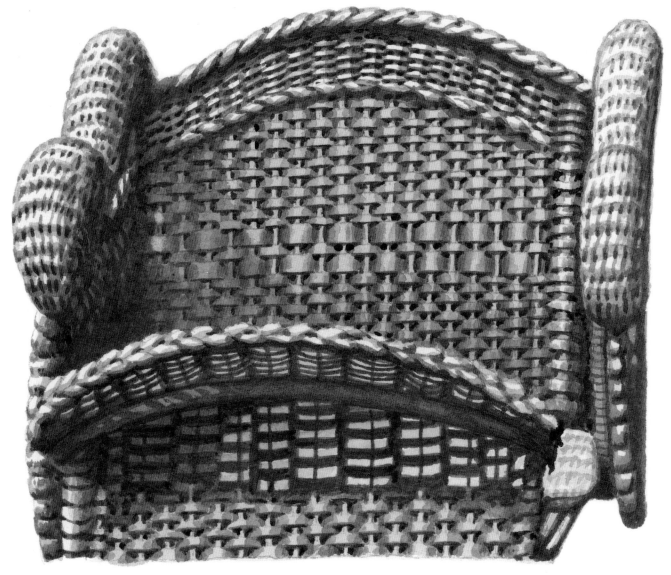

STEP 3

Once you complete the pattern, model the in-and-out weave with additional values of color, emphasizing the construction with triangular shadows that also accent the vertical reeds. Due to the curvature of the back, the modeling tones should get slightly deeper toward the bottom. Form the top and curve of both sides, then carefully detail the weave with darks between the reeds. Put in the dark weave of the inner left side, noting its reflected light. Do the same for the front to achieve its see-through effect. Add a few dark accents on the tubular construction, and finally clean away some spots of color, then stop. Don't overwork it.

HANDS ON!
Eleven Complete Painting Demonstrations

CATSKILL HORSE FARM, 14" × 21"

Michael P. Rocco AWS

SILK FLOWERS AND FLAG

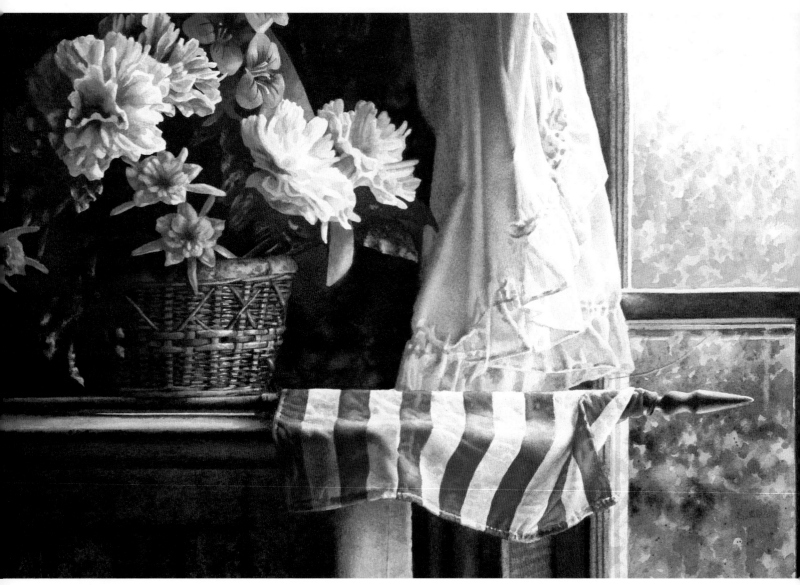

I found the components of this scene in one of the so-called "collectible shops." While browsing alone I saw the flag, but the composition needed more. I spied the basket of flowers and positioned it before I photographed the scene. The pale red flowers in the bouquet gave a good balance of color with the flag. I generally compose my photography with a painting in mind. Here I wanted the flowers to drift off the painting in order to focus attention on the entire composition.

SILK FLOWERS AND FLAG
14" × 21"

COLORS

- Lemon Yellow
- Cadmium Yellow
- Yellow Ochre
- Raw Umber
- Burnt Sienna
- Alizarin Crimson
- Cerulean Blue
- Olive Green
- Hooker's Green Deep
- Warm Sepia
- Sepia
- Neutral Tint

STEP 1

Draw the flag first directly onto the stretched watercolor paper. Try to make all the horizontals of the composition perpendicular to the vertical, for you want a flat perspective to counterbalance the line of the flag. Also make a drawing on tracing paper of the wicker basket should you need it later.

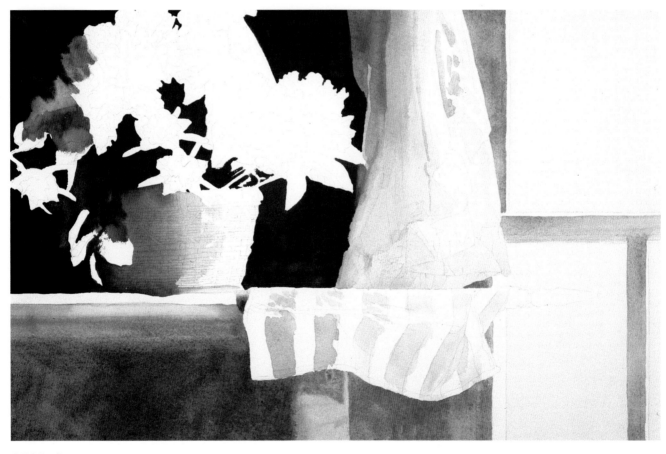

STEP 2

Paint the light of the window first, and follow with the pale colors of the curtain. While the area is damp, blend the shadow color on the upper left. Then paint pale shadows on the white stripes of the flag, and allow all this to dry.

Put in first colors of the window frame to establish value relationships. Then wash in the shadowed face of the cabinet with a broad brush. Let this area dry.

Now you want to affix the drama of the composition with the dark background. Working in one section at a time, outline the flowers with a small brush, then fill that area with a no. 12 brush while the lines are wet. To give a feeling of light, some areas are more transparent than others. Brush in the shadow of the basket, blending with clean water to establish some form.

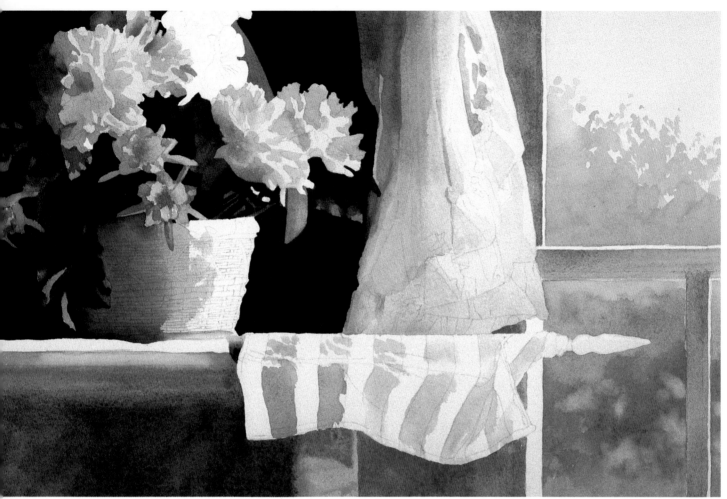

STEP 3

Apply the pale greens of the outside foliage in the window
area, working around the finial of the flagstaff. While this
is drying, paint the various cream colors of the large flowers,
and allow them to dry also. Next put in the pale blue of
the small flowers, working in some deeper tones as you go.
Now work on the leaves, painting their highlights first then
adding shadows.

Start forming the large flowers with pale shadows, and
drop in the color centers of the small flowers, adding darker
tones throughout where necessary. You'll want to move the
bouquet along as a unit with one possible exception: The
pale red flowers can be left for later if you feel their color
would be too distracting at this time.

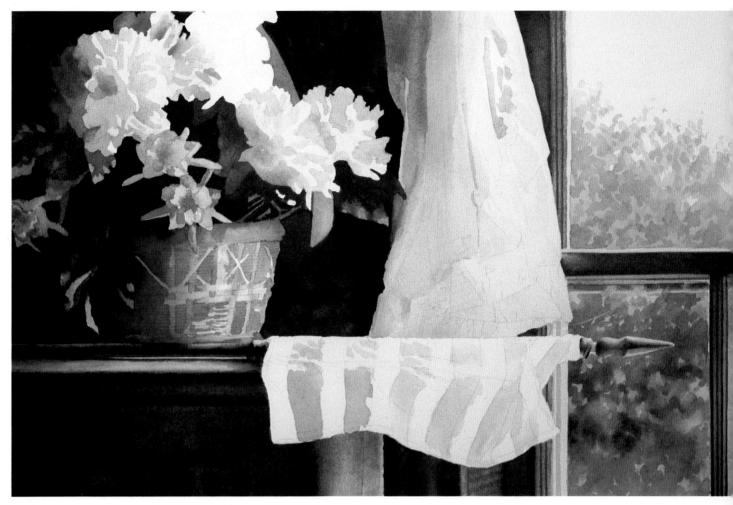

STEP 4

Deepen the value of the window frame, putting in all the darks to establish planes and moldings but also capturing the reflected light from the curtain. Add saw marks in the wood of the inner vertical frame to enhance the realism.

To finish the entire window area, paint deeper color to the foliage, working some areas with a wet-into-wet technique and dropping clean water in spots for further leafy effect. Let this dry.

Deepen the shadow of the basket, blend it into the background, and begin the details of the basket weave. Next concentrate on the cabinet; working on the light side, form its rounded edge. Darken the value of the round edge of the top but hold its subtle light, then deepen the value of the shadowed face, blending it into the round edge of the side.

Paint the dowel of the flag, blending color to form its shape and add the shadow it casts on the cabinet. Paint some initial form into the finial.

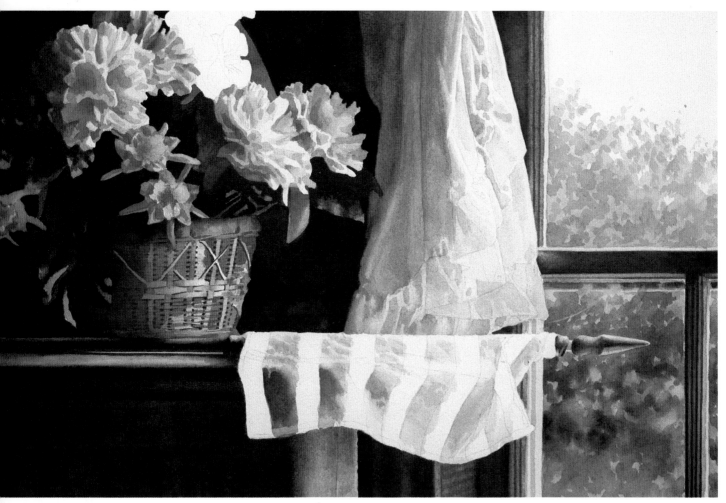

STEP 5

Now go back to the curtain, blending color into the soft folds
and bringing down values in the shadow area to gently fade
into the background. Work this area carefully so you don't
lose the feeling of sheerness in the fabric.

Next, tone down the shadow values of the white stripes
of the flag, adding dry-brush texture to the fabric.

Then focus on the flowers, painting more shading and
color, especially on the smaller ones. Enhance the details
of the basket weave. It's best to move about the composition
developing all these items in a general manner.

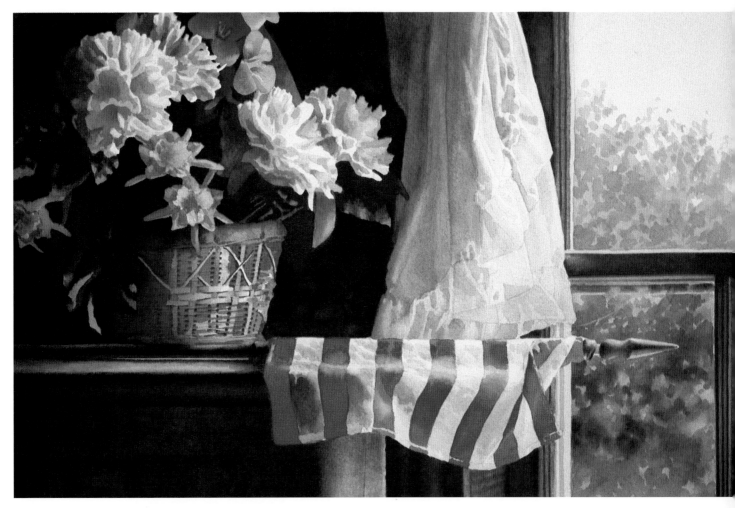

STEP 6

Study what you have done so far. Now is the time to add the reds to the flowers and the flag. Paint a pale red over all the stripes, and allow it to dry. Blend a slightly deeper tone into the first wash for a soft gradation of shading, and add deeper reds to get the feel of the flow of the material.

Handle the flowers in the same manner, except here work a section at a time in a wet-into-wet technique to achieve a soft blend of color on the petals. Once this area is dry, fill in the background where necessary.

On the next several pages, we'll look more closely at painting the important details of this composition: the flowers, the flag, the basket and the sheer curtain.

A Closeup Look at the White Flower

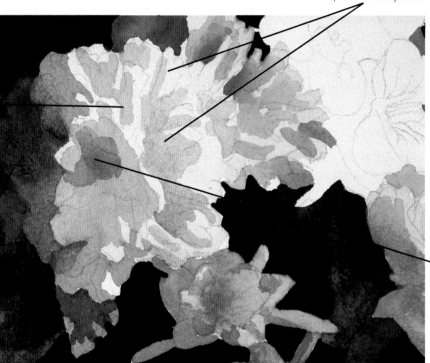

1. Apply a pale wash over the entire flower, and work in a pale yellow while the area is slightly damp but dry enough to control the spread of the yellow.

2. Add pale shadows.

3. Blend the dark left side into the background.

4. Deepen the value of the center of the flower to feel its depth.

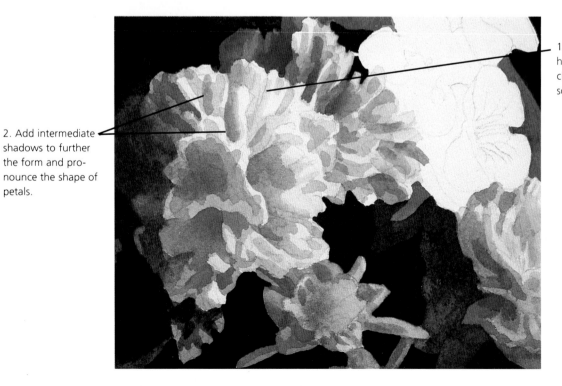

1. Wash away some harsh edges with clean water for a softer feel.

2. Add intermediate shadows to further the form and pronounce the shape of petals.

1. Wash away some color in the extreme shadow to subtly form petals.

2. Noodle color into the pale shadows, blending to give a gentle roll to petals.

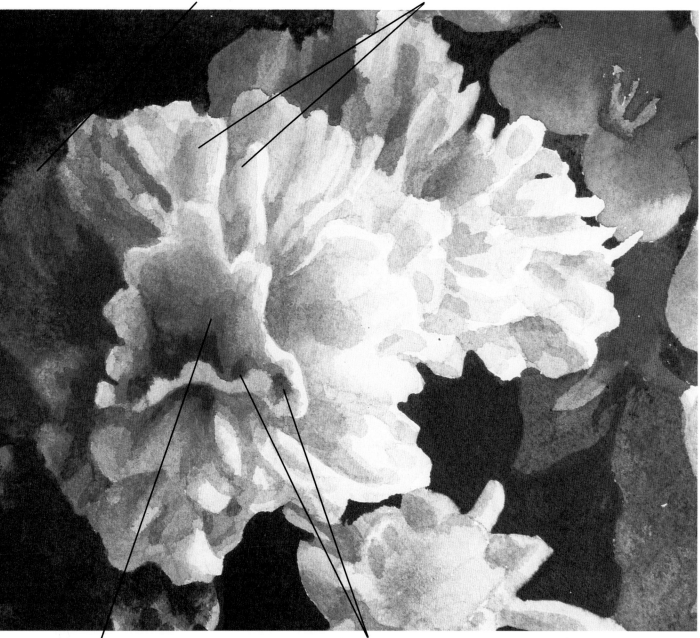

3. Work the center area wet-into-wet for a gradual blend.

4. When all is dry, noodle in the dark accents.

A Closeup Look at the Flag

1. Paint the first pale shadows, varying the color, leaving white paper as highlights.

2. Paint the pale red in all the stripes.

3. Add a slightly deeper tone to all, and follow with a third value to form the flow of the material and establish the light.

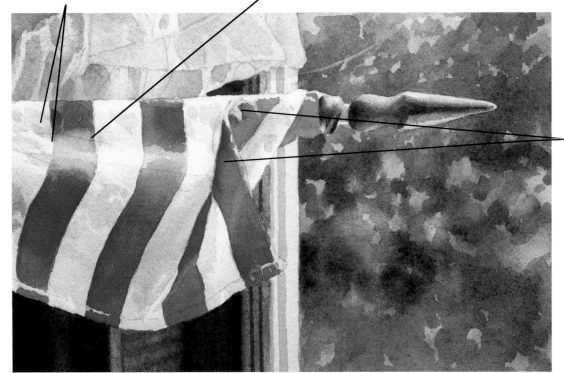

1. Work the shadows of the white stripes gradually down in value, incorporating reflected light and changes of color to capture the puffiness in the material and the subtle wrinkles.

2. Paint the red stripes, blending subtle shading and drybrushing texture. (Let the edge stitching show.) The reds are not pure. They contain a great deal of Burnt Sienna.

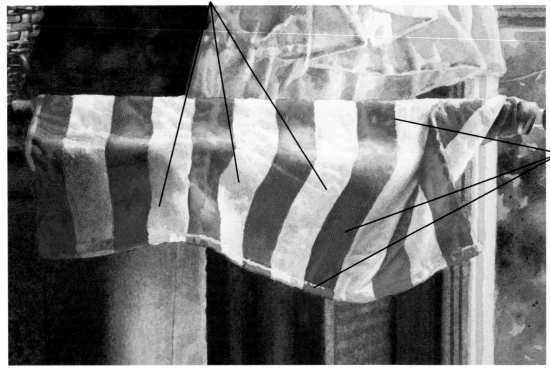

1. Noodle texture into the material, accent wrinkles and creases, deepen values.

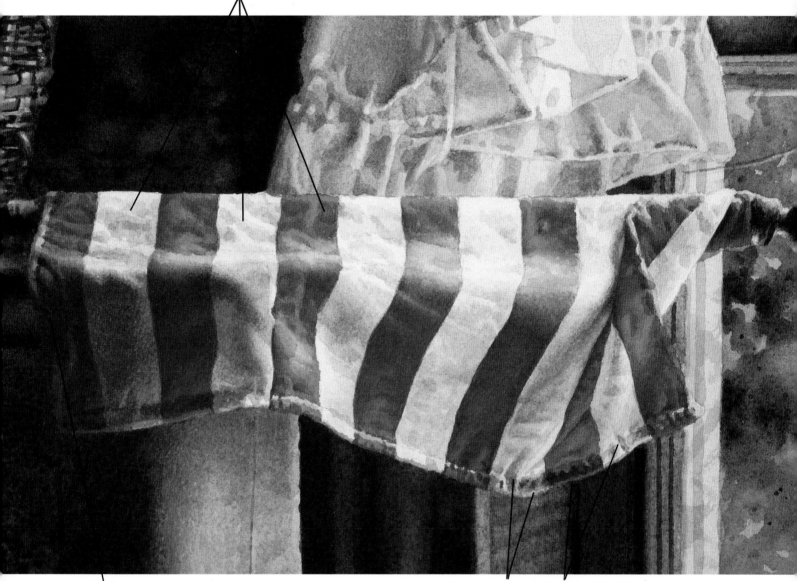

2. The darks here give substance to the cabinet under the flag and unite the flag with the rest of the composition.

3. The darks of the bottom edge add to the feeling of light passing through the material. Be careful to retain reflected light on this edge.

A Closeup Look at the Basket

1. First give the basket a simple wash to get a feeling of its form, then deepen the wash to blend into the background. After this dries, add a wash of pale yellow to the remaining area and let this dry also.

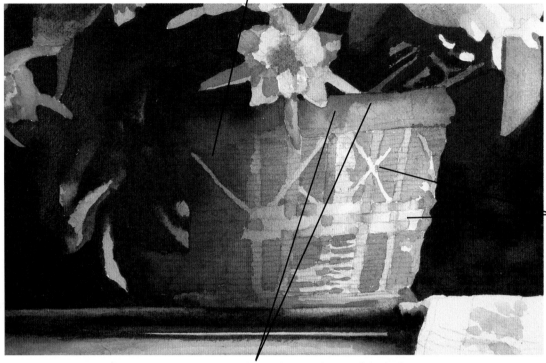

2. With an intermediate tone, paint over this wash, leaving areas to form diagonals and verticals and avoiding some highlights on the horizontals.

3. Blend colors into the top of the basket to start its contour.

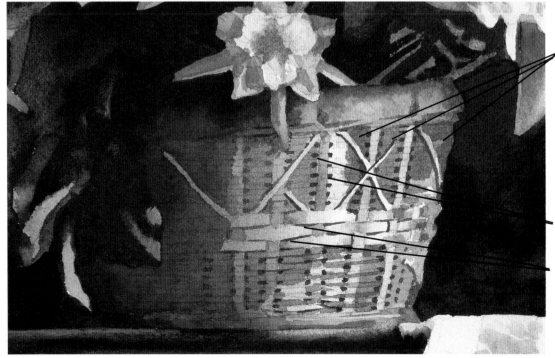

1. Deepen the color on the body, accenting its structure and shape.

2. Delineate the weave with shadows, especially on the central horizontal bands, where you also want to capture the slight curve within the strips because they are not perfectly flat.

1. Deepen some areas on the body to further the structure and form.

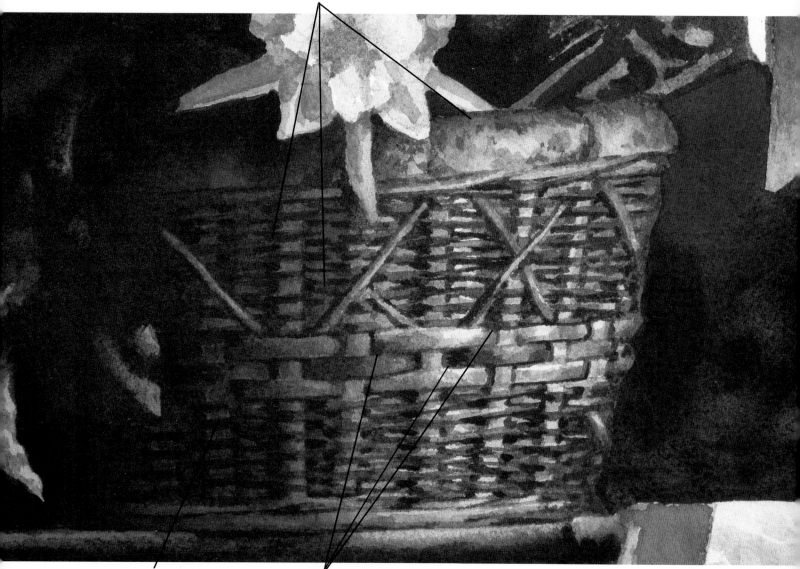

2. A subtle vertical within the shadow implies the basket's roundness.

3. Detail the weave with shading and by strengthening shadows, fading the horizontals into the background.

A Closeup Look at the Curtain

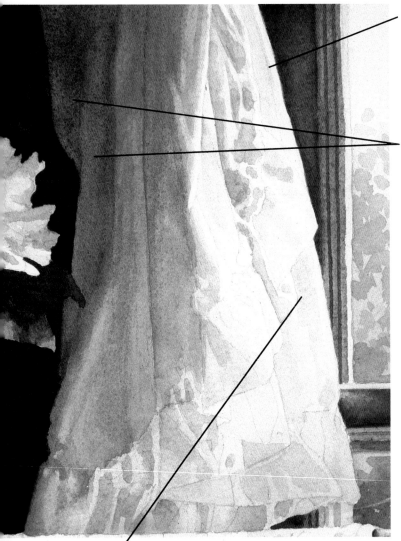

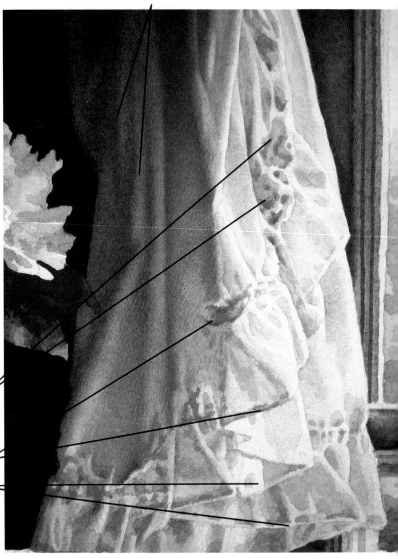

1. Start with an overall pale wash, varying the color as needed while the area is damp. Don't let the color dry with harsh edges. That would take away the feeling of softness.

2. On the shadow side, intensify color and darken shadows, developing folds as you go but blending with clean water as the darks near the light areas. No harsh edges.

1. Gently tie the extreme darks into the background, accenting the soft roll of the folds to give the feeling of overlapping material.

3. Add subtle shading to the folds in the light area, with changes of color caused by the window frame. These changes increase the feeling of translucency in the fabric.

2. Blend more soft shading in the light areas to further the intensity of light.

3. Add final accents to the ruffle and hemline, but retain the reflected light on the bottom edge, which brings the edges away from the window.

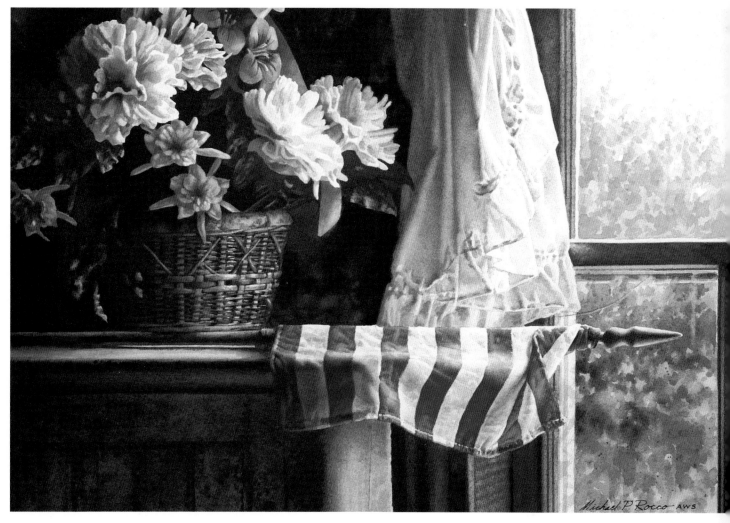

FINISH

Noodle the painting to completion, blending colors from
light to dark while they are fresh, to achieve the subtle
interplay of color and a gradual blend. Wash away a line of
color for a crack in the window glass, and accent it with a
dark line. To add more meaning to the glass, apply pale color
for water stains and wash away some foliage color to ex-
tend these stains. Finally, splatter this area with pale color,
covering parts of the painting with paper to prevent un-
wanted spots.

CATSKILL HORSE FARM

STEP 1

Wet your stretched watercolor sheet completely with clean water, then apply an overall wash of pale Payne's Gray with a 1-inch flat brush. After this dries, paint the sky, and while the area is still damp, put in the hazy trees of the background and establish the line of the snow-covered roof of the shed. Blend soft shading into the snow, and stipple in the distant trees with a brush. For the shed on the right, paint the light colors of the clapboards and window frame first, then blend intermediate values using a dry-brush technique. Follow this with shadows and darks, drybrushing at times, to achieve a weathered look.

STEP 2

In the background, stipple darker values in the trees and increase the solidity of color as it nears the line of the field, yet retain a snowy effect on branches. Paint the vague trees in the distance, then add the closer ones using a dark color for their trunks and branches. Drybrush some weeds into the field and near the barn on the left. For the lacelike pattern of the weeds in front of the barn, paint the dark color of the weathered shingle siding in between and around stalks and leaves.

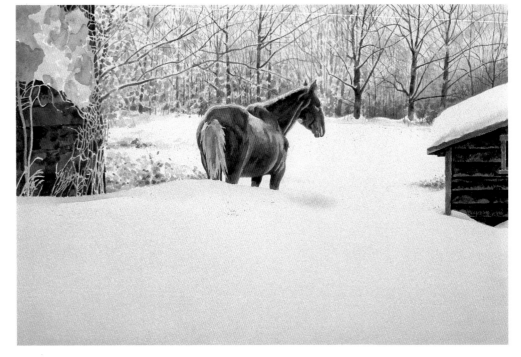

STEP 3

It's time to work on the horse. To discern muscle and bone structure, paint the highlights lighter in value than they eventually will be. Values will gradually deepen, and color changes will be blended into the lighter tones. Use the point of a no. 2 round brush, employing short strokes to gain texture as well as form. To achieve the sheen of the horse's hide along with texture, be sure your brushstrokes are directional following the contours of the body.

CATSKILL HORSE FARM
14″×21″

STEP 4

Continue painting the horse, building color on color, strengthening the darks, following its form with your brushstrokes. Go back to the intricate weeds, painting spots of darker colors over the light underlaid areas to form the web pattern of twigs. In this manner, you are completing the barn siding as well. The distant trees and the weeds between the horse and barn can be deepened with additional stippling. Wash and scratch away some color from the horse's belly to form more weeds. Put in the dark stems of the brush near the barn and a lone twig to complete the painting.

COLORS
- Yellow Ochre
- Alizarin Crimson
- Chrome Orange
- Burnt Sienna
- Cerulean Blue
- Payne's Gray
- Neutral Tint
- Warm Sepia

COLONIAL PLANTATION

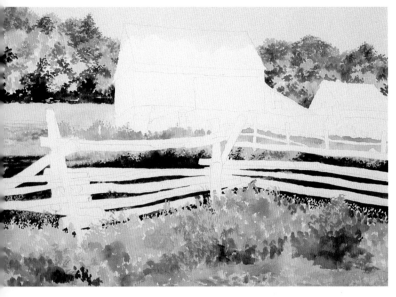

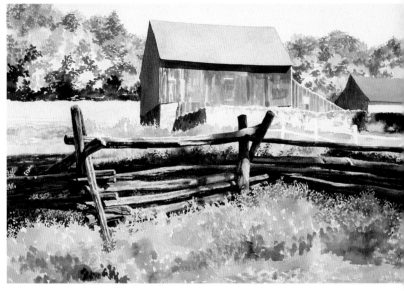

STEP 1

First paint in the sky color, and while this area is drying, put in the pale greens of the distant field. In the foreground, use various greens to start the formation of weeds and grasses. Also add light earth tones near the bottom of the composition. Proceed with the background trees, here again using different tones of green to establish form and adding the dark green shadows to gain the edge line of the field. Now apply the dark greens of the shadows behind the fence, structuring it as you go. All of this should be handled loosely.

STEP 2

Paint the sunlit wall of the small barn, and give the stone wall in front of the barns its first colors. Next apply basic colors to the side of the large barn. Keep your brushstrokes vertical to follow the direction of the siding. Add color to the barn roofs, and paint the shadow sides of the barns, noting reflected light. Start work on the fence by putting in all the various light colors, then adding drybrushed texture for the rough-hewn character of the rails. Follow this with the shadows further detailing the rails, giving them shape and direction to the cross supports. For rails in the extreme shadows, wash away some color on their edges.

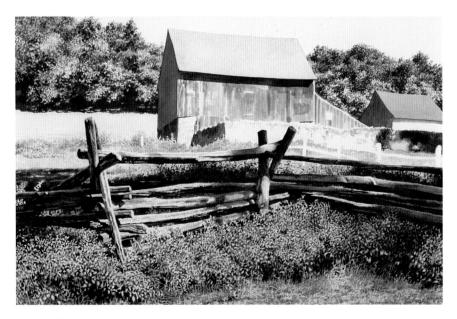

STEP 3

Paying attention to light and form, bring the background trees to completion, using a no. 2 brush in an almost Pointillism technique to gain the feeling of leaves. Further texture the distant field with deeper tones of green and other earth colors. Paint the foreground weeds by overlaying color of progressively deeper values, in an overall manner, to the underlayment of lighter color, shaping leaves and stems as you go. (Review the texturing demonstration on "Tall Grasses" on pages 24-27.) Texture the earth tones to simulate pebbles.

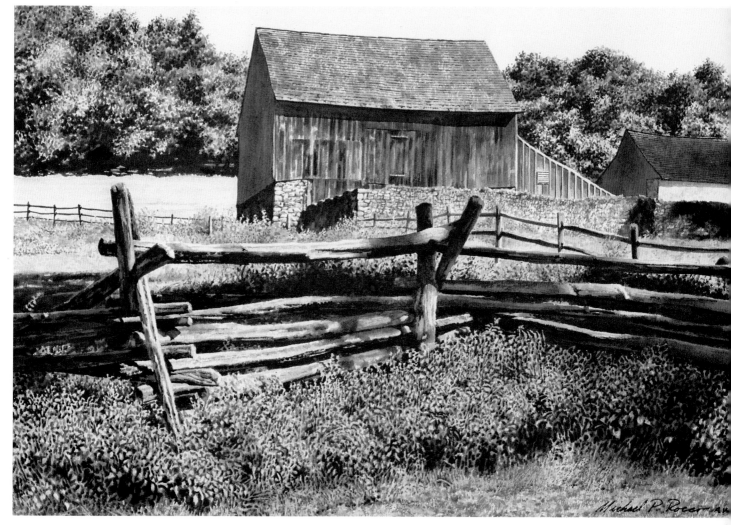

COLONIAL PLANTATION
14″×21″

STEP 4

Now work on the roofs, adding areas of deeper color, dry-brushing for texture and lines for shingles. Give the side of the small barn a feeling of stucco. With variations of color, detail the stone wall in front of the barns, and add the dried vegetation that clings to it. Finish the wood siding and the stone foundation of the large barn. Paint the final details: the fence on the right that leads the eye back to the barn, and the one in the middleground field.

This structure is part of a re-creation of a Pennsylvania farm from the 1700s, where visitors can witness the working activities of that time. Many of the buildings have been standing since the eighteenth century, but the barn is a recent reconstruction using traditional tools and methods.

COLORS
- Lemon Yellow
- Yellow Ochre
- Olive Green
- Hooker's Green Deep
- Payne's Gray
- Burnt Sienna
- Alizarin Crimson
- Neutral Tint
- Warm Sepia
- Raw Umber

FARMHAND, CIRCA 1860

STEP 1

With a no. 12 round brush, give the wall a roughly scrubbed wash of pale color (leave the figure clear). On the lintel, however, follow the grain of the whitewashed wood. Establish the wall's thickness by adding shadows to its return. Drybrush additional tones onto the wall, developing the stucco. Paint the light colors of the seam, crossboard and knots on the shutter. Then paint the overall colors, avoiding those previously painted sections. In the doorway area, dampen the paper then apply the dark color using just enough water to make it flow properly.

STEP 2

Paint the farmhand's head and neck in an initial flesh tone. Put in the crown of the hat, and follow this with the blue of the shirt. Allow each of these areas to dry between coverages. Next start forming the features of the head and neck with deeper flesh tones. Add shadows, folds and creases to the shirt, and wash away some of its color, giving softness to the material. Paint the underside of the brim, bringing this color down into his hair.

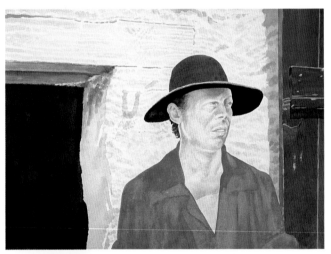

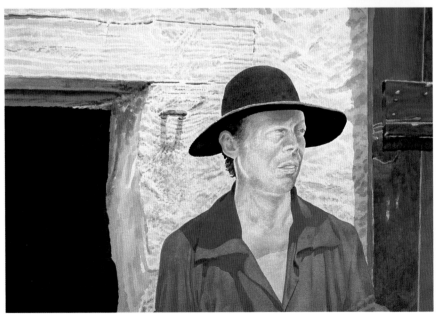

STEP 3

Add more detail to the stucco wall, accentuating its irregular surface with dry-brush texture and light-value shadows. Treat the lintel in the same manner and delineate its outline further. Strengthen shadows and texture on the doorway wall. Deepen the shadows of the folds of the shirt and on the shoulders. Using the point of a no. 2 round brush, shade the crown of the hat for form and texture.

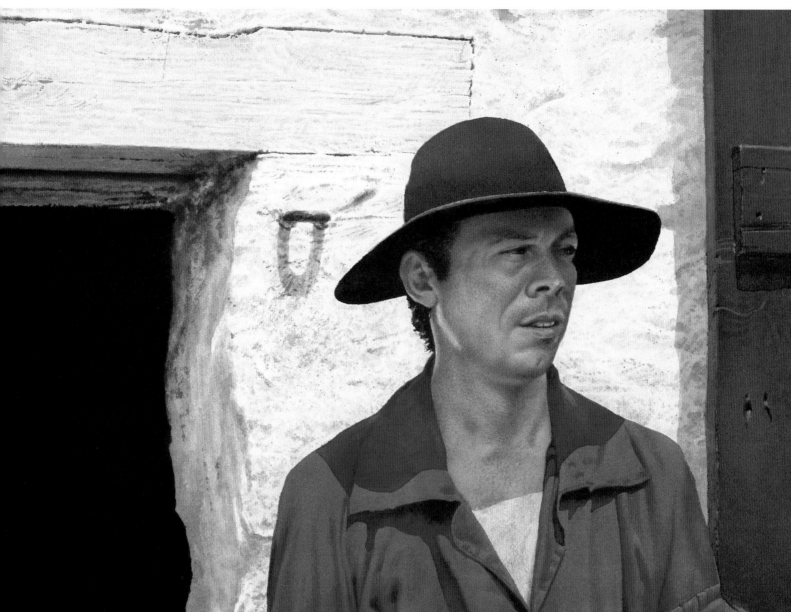

FARMHAND, CIRCA 1860
17″ × 23″

STEP 4

Begin modeling the head using the same brush and technique as on the hat. This gives the porous look of the skin. Work on the head as a unit, structuring its overall form, bringing flesh tones down in value to put the head in shadow, yet retaining reflected light, which is so important to the contours. As you paint, think as a sculptor—three dimensionally. Structure the features slowly, feeling the pull of muscle and bone. Deepen the value of the forehead, making it recede softly into the hat. If you feel the shutter commands too much attention, you can bring its value down.

COLORS

- Lemon Yellow
- Cerulean Blue
- Yellow Ochre
- Raw Umber
- Cadmium Red
- Alizarin Crimson
- Payne's Gray
- Neutral Tint

FLOWER CART

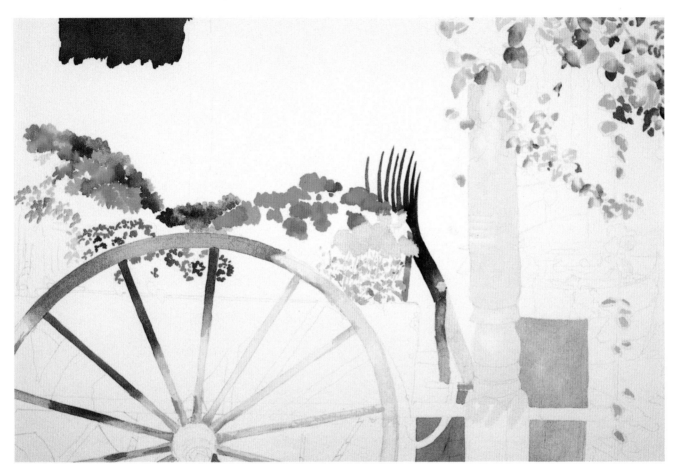

STEP 1

Strong light, dramatic shadows, good texture. There is a lot
going on in this composition, so draw it carefully, though
loosely, on your stretched watercolor paper. Paint the vari-
ous yellow-greens of the leaves and stems of the vine, and
then the color of the flowers and some leaves on the cart. Put
in the post, wheel, and first shadows on the wheel. Paint
an area of Yellow Ochre that is a wood crate, plus a patch
of Payne's Gray, which represents a window in the back-
ground. Add some shading to the flowers, and paint in a
wooden pitchfork behind the cart.

COLORS

- Lemon Yellow
- Cadmium Yellow
- Yellow Ochre
- Raw Umber
- Chrome Orange
- Cadmium Red
- Alizarin Crimson
- Cerulean Blue
- Olive Green
- Hooker's Green Deep
- Neutral Tint
- Sepia
- Payne's Gray

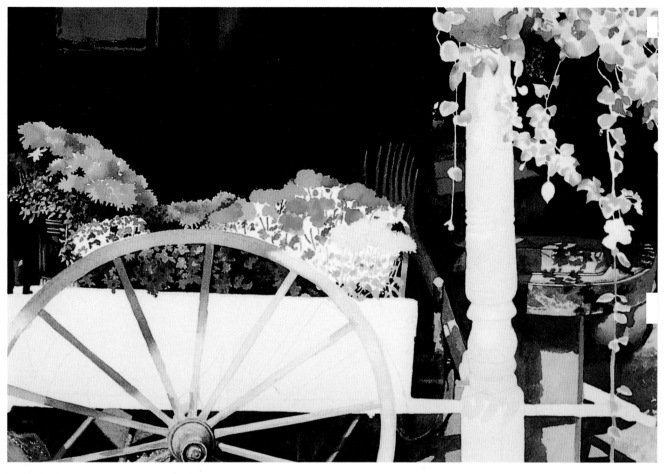

STEP 2

Add more color to the flowers and leaves of the plants. Paint the shadow on the crate to create depth.

Now to the drama and strong contrasts of the dark background. Working in one section at a time, outline the contours of the leaves and stems with Sepia color using a no. 2 round brush. Fill the area using a larger brush, then move to another section and proceed in the same manner. Handle the large area behind the flowers in the same way, except outline the flowers with a general shape. Details will come later. To fill this area, use a no. 12 round brush and keep the color flowing. Add the lights and darks under the cart, accenting the wheel, and develop the hub of the axle for dimension.

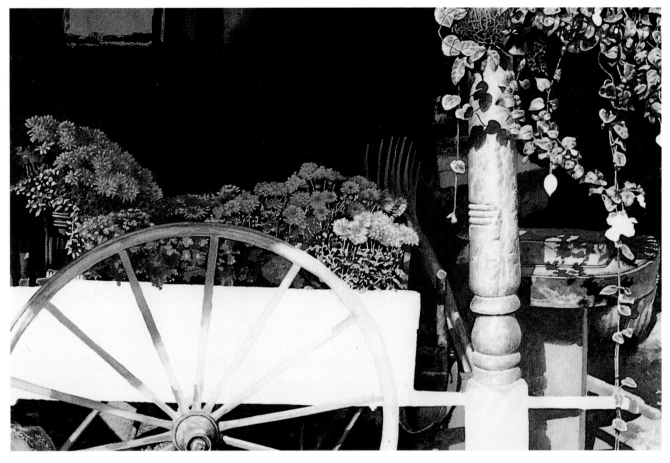

STEP 3

Paint an intermediate shadow over the flowers, giving the feeling of dimension. Work on the blossoms as a unit, before detailing individual shapes. Focusing on the post, blend shading to form it, painting all the turnings, adding the texture of its time-worn features, accenting cracks and hollows. To achieve the tangled characteristic of the container at the top of the painting, apply deeper spots of color over lighter values. Drybrush rough texture onto the crate and the ground. Then bring the shadow on the wheel rim to its proper value.

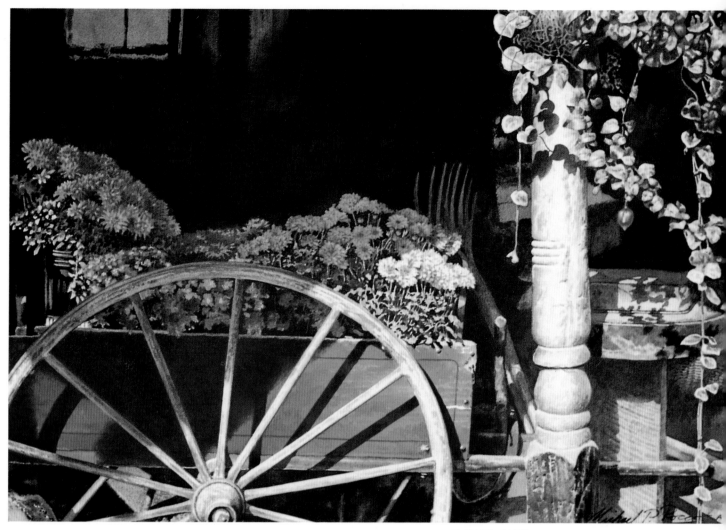

FLOWER CART
14" × 21"

STEP 4

Finish the bottom of the post, painting the light colors first
and following with intermediate tones. Then put in shad-
ows and darks accenting cracks and bumps. Add blossoms
to the vine. Work on the cart, painting exposed wood then
adding the faded red of the side and handle. The interesting
shadow on the side sets the wheel away from the cart and
gives continuity to the shadows elsewhere. Detail the spokes
and rim with the same careful attention to their shape and
texture.

FROZEN POND

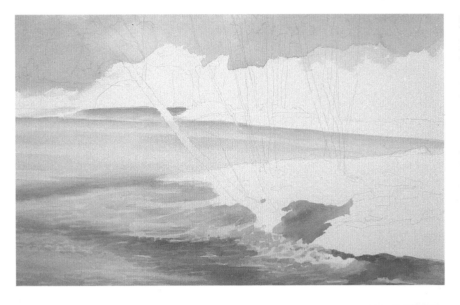

STEP 1

Paint the sky area onto the dry sheet. There is no reason to prewet the paper for such a small portion. Bring the color wash down far enough below the tree line so it will be seen in the final stages. Similarly, paint the middle and foreground, blending deeper values while this area is still damp. These values represent changes that occur on the frozen pond. At times, drag your brush across the paper to give texture to the irregular ice.

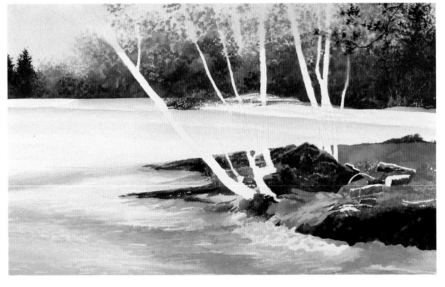

STEP 2

For the sparse foliage of the background trees, use a great deal of stippling and dry-brush technique. Stippling more densely and in a darker color in some locations gives a fuller effect and overlapping branches. As the foliage and trees come closer to the pond, paint the color more solidly, with variations in hue, to avoid a flat look. Apply first colors to the point of land in the middle ground, establishing form, shapes and values. (Leave the major tree trunks clear.)

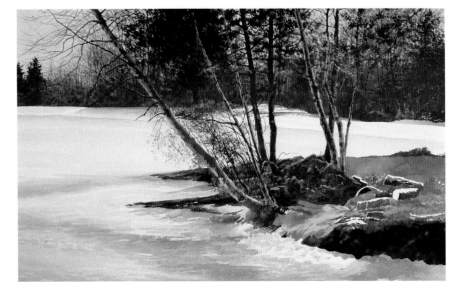

STEP 3

Develop the background trees with more stippling. Paint tiny branches against the sky in a pale color with a small, thin-haired brush. Heavier branches can be painted with a no. 2 round brush and a darker color. Stipple twigs and weeds on the point of land, then start painting the trees. Lay in all the light color of the trunks, then add the darks, blending wet-into-wet at times for softness of form.

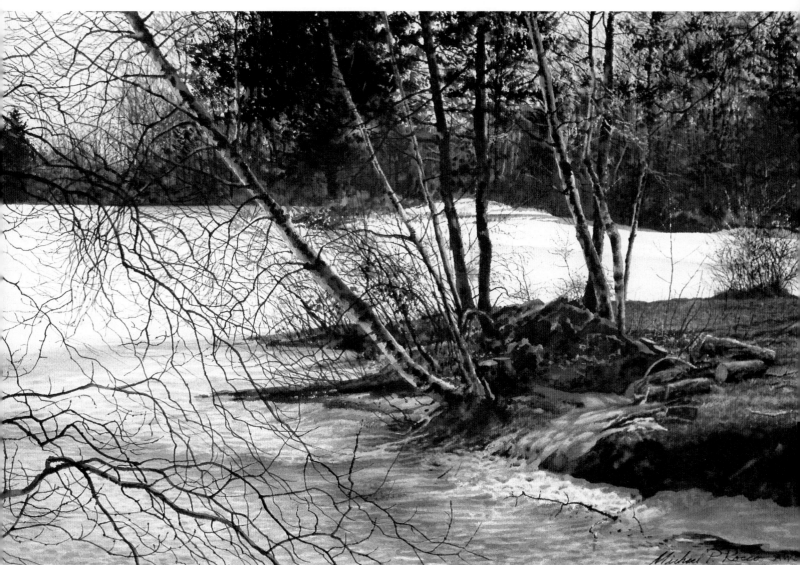

FROZEN POND
14″ × 21″

STEP 4

Now concentrate on the middle ground, overlaying colors on the patch of deep orange to achieve a ground full of fallen leaves. Clean away some color for lighter leaves, adding shadows for definition. Scratch away color with a craft knife to give sparkle to some branches.

Work on the pond in the foreground, deepening its value and heightening the contrast relationship with the distant area. Paint in the rippled and irregular formation of the ice. In the left foreground area, paint branches in a rhythmic manner with a small thin-haired brush.

COLORS
- Yellow Ochre
- Raw Umber
- Chrome Orange
- Burnt Sienna
- Olive Green
- Hooker's Green Deep
- Cerulean Blue
- Warm Sepia
- Sepia
- Neutral Tint

HOLIDAY WREATH

STEP 1

After drawing the image directly on your stretched water-color paper, paint a thin, light gray line over your pencil lines, defining all the shapes of the wreath and window frame. Once dry, erase the pencil lines from this area. To establish the contrasts immediately, paint all the darks of the window panes and the wreath. Use variations of color within the darks, and in some areas, use blends of wet-into-wet.

STEP 2

Give the window frame a wash of pale warm color and let this dry. Follow with an intermediate value to form rough paint texture. Paint the shutter on the left by first putting down all the light color of the weathered wood. Then with the lighter green, drybrush texture to the first color, emphasizing its cracked, blistered appearance. Follow with the dark green, adding texture to the previously painted sections.

The decorations at the bottom can be painted to a near finished condition before focusing your attention on the wreath.

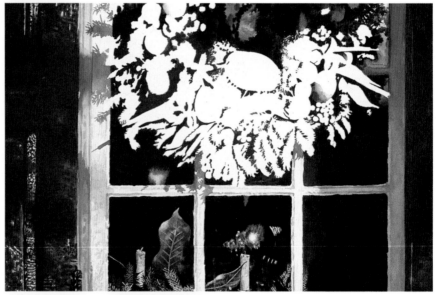

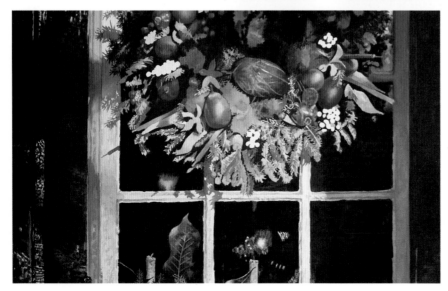

STEP 3

Paint the pine branches in various hues of green to give them dimension and veracity, paying attention to their structure and complexity. (Note the Yellow Ochre stems that appear every so often.) Lay in all the basic colors of the items on the wreath except the red berries. For most of the fruits and nuts, use wet blending of color to give soft shading to their form. The large leafy object can be tricky, but try to capture all the color changes and prominent veins along with its shape.

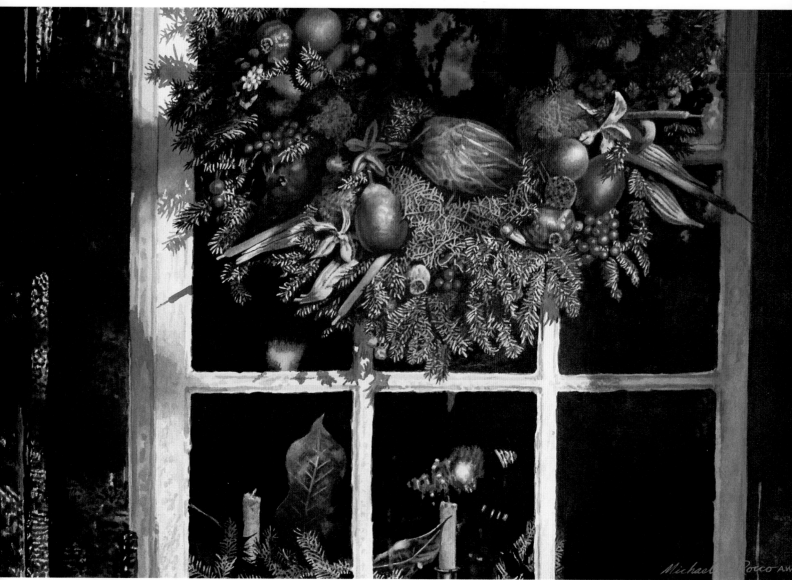

HOLIDAY WREATH
14″×21″

STEP 4

Using a no. 2 brush with its fine point, detail the pine completely, adding shadows from overlapping branches and needles, washing away color for highlights, paintings nubs on the stems. Paint the strawlike material in the center with progressively deeper spots of color over the lighter underlayment, forming the tangled stems. Finish the remaining items, being aware that the wreath has to work as a unit. Now paint in the red berries.

Some areas of the wreath should be more in shadow, so apply a wash, deepening the value where necessary, then rework the details.

COLORS
- Lemon Yellow
- Yellow Ochre
- Raw Umber
- Chrome Orange
- Burnt Sienna
- Alizarin Crimson
- Cerulean Blue
- Olive Green
- Hooker's Green Deep
- Payne's Gray
- Neutral Tint
- Warm Sepia

JUG AND ROCKER

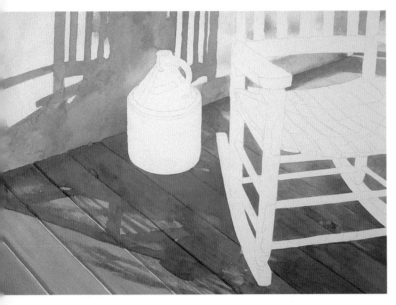

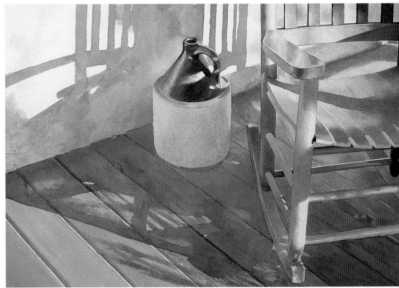

STEP 1

Give the entire sheet a wash of pale Yellow Ochre, then paint a basic light color to the porch floor, even in the shadow area. Your brushstrokes should follow the diagonal direction of the boards.

Mix an ample amount of color to paint the rhythmic shadows from the chair on the wall in one effort, keeping the color flowing. Use the same procedure on the floor, except here, variations of color occur within the shadow.

After this dries, go back over the boards individually with color slightly deeper than the original, leaving the edges highlighted to give them dimension. Put the leaf in for color.

STEP 2

Paint the light tone of the rocker's backrest, and while still damp, blend in its soft shadows. Then move to the seat, and follow the same procedure. Painting in small areas enables you to take advantage of the dampness of the paper.

Handle the base of the jug with a wet blending of color to achieve its roundness. But on the dark upper portion, paint definitive color areas, which can be blended later.

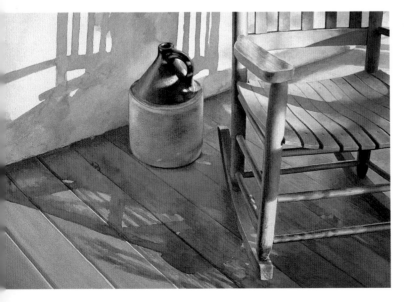

STEP 3

Now go over the entire chair, gradually deepening shadows, forming the turned legs and rungs, being aware of the reflected light that adds to their roundness. Blend darker color on the seat, accenting its compound curves, and finish with lines dividing the slats.

Noodle the base of the jug with progressively deeper values of color, working in from both sides, with the deepest tones toward its center. Blend intermediate colors in the upper section, working it into the look of a smooth, glossy surface. Wash away some color for reflected light. For most of this work, use a no. 2 round brush.

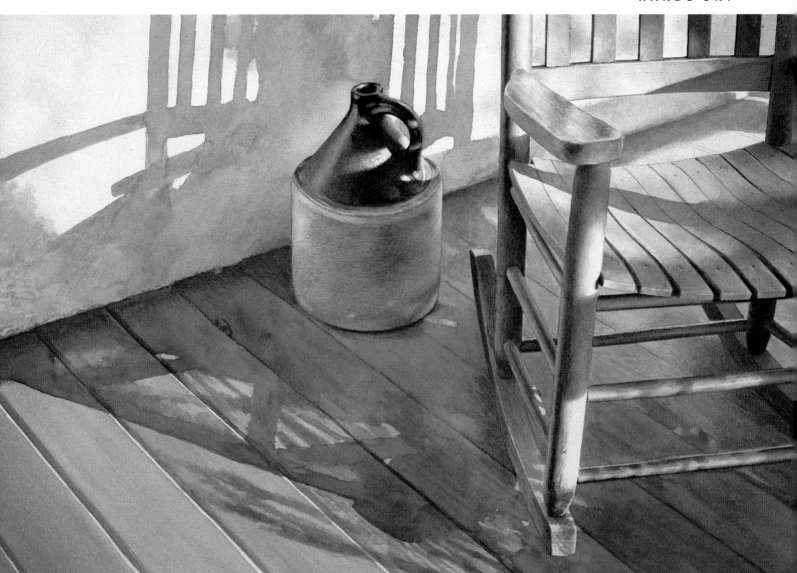

JUG AND ROCKER
14″×21″

STEP 4

Detail the porch floor further with color changes and wood graining, noting nail depressions by washing away specks of color and underlining them with darks. The perpendicular saw marks on some of the boards can be achieved by first washing away color to form the ridges then accenting the valleys in a deeper tone. Finish the painting by drybrushing more texture onto the irregular surface of the stucco wall.

At first glance this seems a rather quiet scene, but it is actually filled with subliminal motion. The shadow cast by the chair onto the porch floor is intersected by the diagonal lines of the board separations. They end at another strong diagonal against the wall, where a staccato of vertical shadows play into the verticals of the chair's back. The curved shadows on the seat point gently to the jug.

COLORS
- Lemon Yellow
- Yellow Ochre
- Cerulean Blue
- Alizarin Crimson
- Neutral Tint
- Burnt Sienna
- Warm Sepia

THE QUILTING SHOP

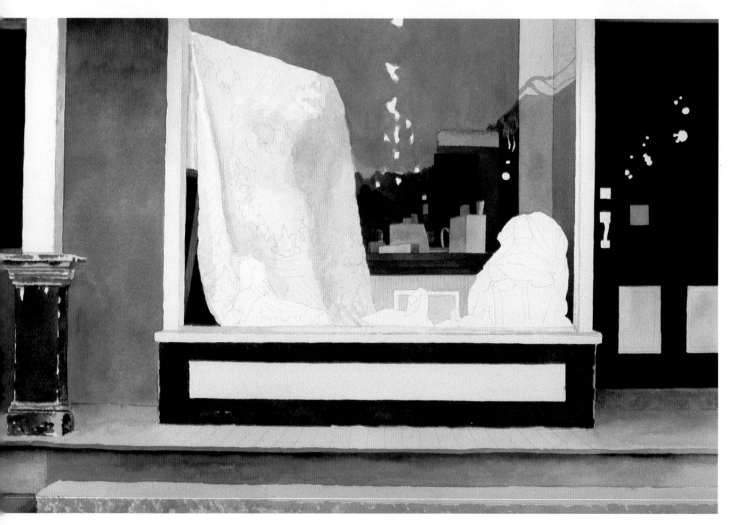

STEP 1

Once the image is drawn on your watercolor sheet, paint all
the light woodwork of the post, window frame, bay and
doors, plus the horizontal and vertical planes of the board-
walk and the concrete step. Lay in the first color of the
wood siding on the left, working around the base of the post.
All these areas should be painted after previous ones have
dried to get clean, crisp edges.

Paint the molding over the doors and on the post base
before you apply the dark green woodwork. Follow with
the intense dark of the door windows, but leave specks of
clean white paper for interior lights.

Now give the quilt and other window items a pale wash
of color and soft shading. Add the column within the shop.
Paint the sky reflection on the glass, thus shaping the quilt
and column. Finally, paint the dark reflections in the glass.
You have now established all the planes in the composition.

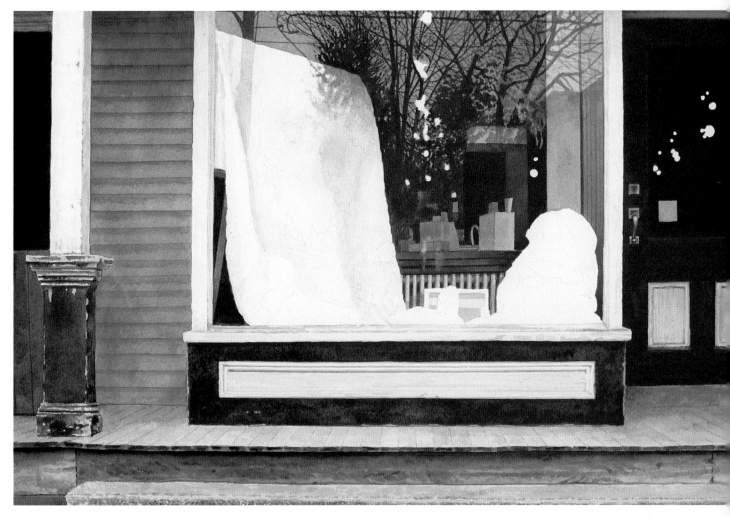

STEP 2

Start detailing and adding character to all that surrounds the
window: peeling paint, moldings, and deep color and shad-
ing that delineate the overhang of the walk and accentuate
its vertical support. Texture the step to resemble formed
cement. Try to capture the "feel" of the different materials
in the composition—wood, glass, cloth, concrete. Then
turn your attention back to the window, painting in more
reflections and detailing the radiator.

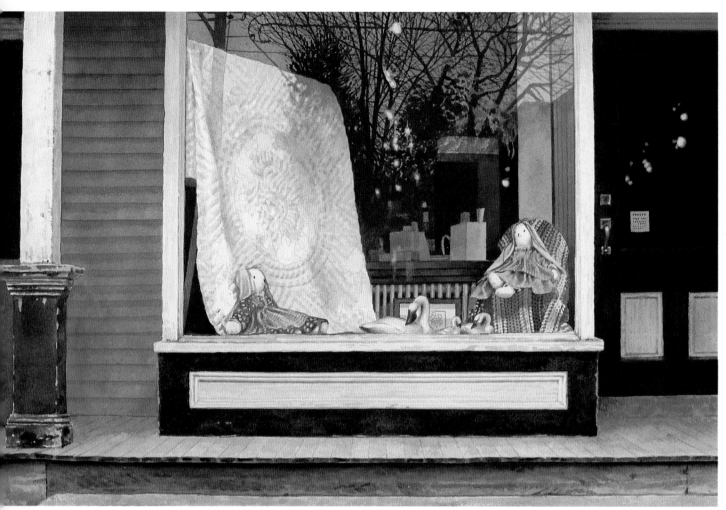

STEP 3

Concentrating on the window items, study the tufting pattern
of the quilt and paint its soft shadows, following the folds
and creases. Use two and three values to achieve this effect.
The stuffed dolls are painted with flat colors except where
wet colors are blended for softness in their faces and folds of
the dresses. The swans are handled in the same manner.
Add color to the spots that were left clean, adding sparkle
and interest to the interior. Also add color to the blanket
under the doll.

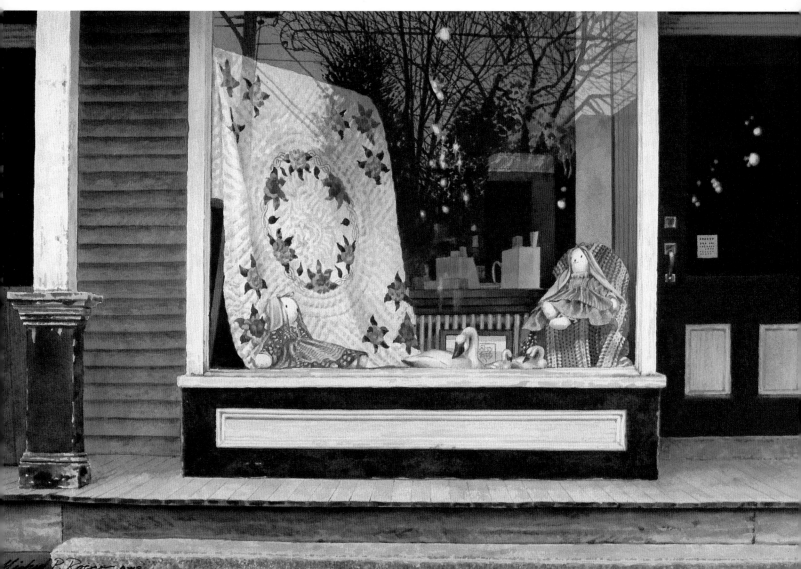

STEP 4

Finally, paint the floral patterns on the quilt. To simplify the procedure, work on one section at a time. Move along the remaining window items in a general manner before you complete their individual detailing. Texture the crocheted blanket, giving it its nubby look with a series of darker colored dots over lighter areas.

Lancaster county is known as Pennsylvania Dutch Country and abounds with shops similar to the one depicted in this painting. Amish and Mennonite women produce beautiful hand-sewn quilts that are works of art in themselves. This shop is a picture from the past whose appearance has not been altered to accommodate modernism, as evidenced by the elevated wooden walk.

THE QUILTING SHOP
14" × 21"

COLORS

- Lemon Yellow
- Chrome Orange
- Raw Umber
- Cerulean Blue
- Permanent Blue
- Alizarin Crimson
- Olive Green
- Hooker's Green Deep
- Payne's Gray
- Neutral Tint
- Warm Sepia

OLD BASKETS

STEP 1

Paint the light color of the windows first, and while these areas are still damp, apply the pale yellows and greens of the outdoor foliage. Next give the entire whitewashed wall a pale color. Using a no. 12 round brush, scrub this wash roughly to simulate the stucco texture. Allow this area to dry.

Paint the light edges of chipped putty and indented wood on the window frames, and follow with the darks, keeping a subtle suggestion of reflected light. Establish the planes of the sill and walls, working in more texture to the stucco.

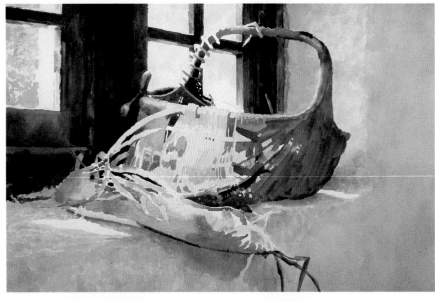

STEP 2

Paint the light colors of the baskets first, then with intermediate tones and shading, give the baskets form. Put in tones to explain the weave and delineate splines of the flat basket that project in front of the large basket. Carefully form the twisted strands of the handle by painting darks around lights. Blend preliminary colors in the upper portion of the handle to establish its round shape. Also indicate the upward curve of the major ribs as they bend around the large basket.

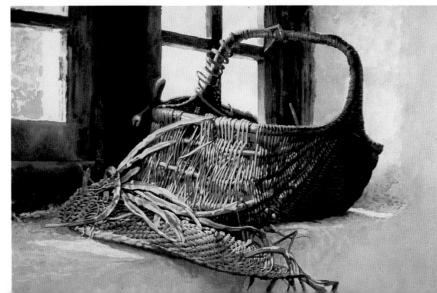

STEP 3

Now work on the weave of the baskets. Accentuate bends with color washes, and paint various values of darks between splines. Develop the shape of the individual strands. Several values of shading on the flat basket form the rows of its weave. Wash away some color from individual strands to accentuate the light. Suggest the weave throughout the shadowed side of the large basket.

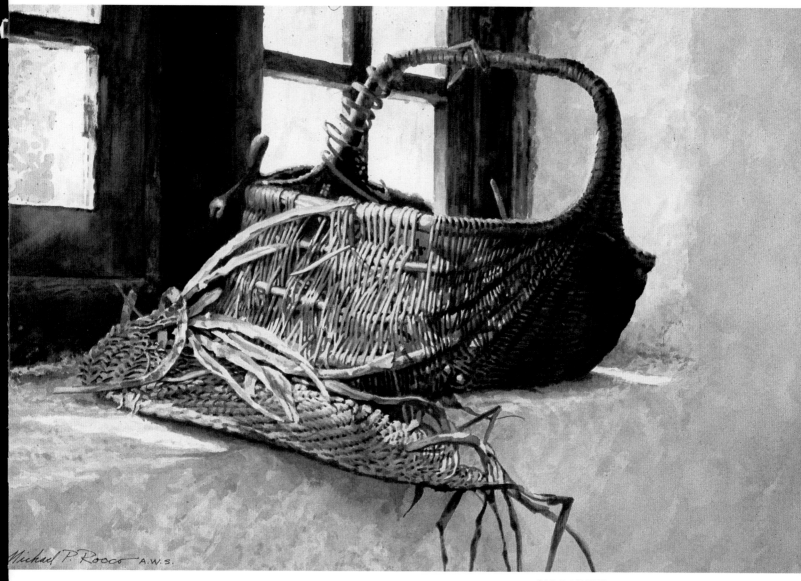

Michael P. Rocco A.W.S.

STEP 4

Add final details to the baskets, washing away specks of color in the shadow area of the large basket for added interest and to assist its hollow feel. Strengthen some darks; this, in turn, intensifies the feeling of light. On the walls, increase the structure of the window alcove with washes of deeper value and by strengthening shadows. More drybrush for the stucco texture and the painting is complete.

OLD BASKETS
14″ × 21″

COLORS

- Lemon Yellow
- Yellow Ochre
- Raw Umber
- Olive Green
- Alizarin Crimson
- Cerulean Blue
- Payne's Gray
- Neutral Tint
- Warm Sepia

VILLATOBAS, SPAIN

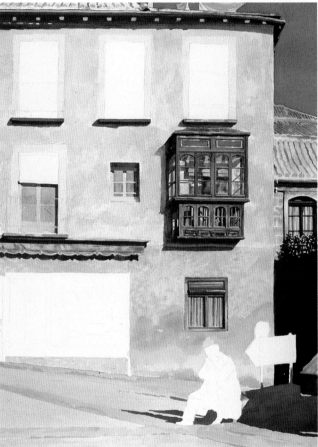

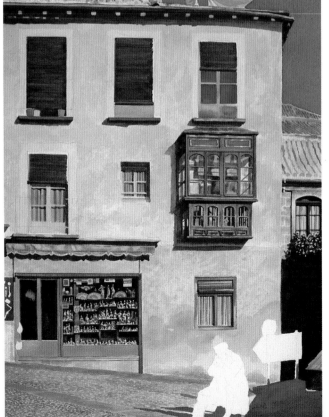

STEP 1

The pale Yellow Ochre of the building is the first color to paint, leaving all the windows clear. This is followed by the pale gray of the cement foundation. To establish values and color relationships, now paint in the sky, again leaving some areas clear.

STEP 2

After painting basic light colors of the cobbled street and slate walk, add some dry-brushed texture to the large wall with a deeper tone. Paint the building at the right almost to completion. The lower windows of the main building, the French doors of the building at right, and details such as the awning and shadows should be added at this point to help you feel depth in the painting.

STEP 3

Now put in all the major colors of the windows, roll-up shutters and wood doors. To simplify painting the display, work on one shelf at a time, completing all statuettes with shadow, form and color, then fill in dark background.

STEP 4

Now start working on the figure. First, paint the general color, the flesh tones and light values of the clothing, then paint intermediate tones to establish form in the head and folds in the coat and trousers. Finally, add the shadows, blending for soft edges.

Paint more texture in the roof tiles and loosely delineate them. Use a small pointed brush to paint in the horizontal lines of the roll-up shutters. Finally, paint all the shadows cast by the railings before adding the railings over them.

COLORS

- Yellow Ochre
- Raw Umber
- Chrome Orange
- Burnt Sienna
- Cerulean Blue
- Olive Green
- Hooker's Green Deep
- Alizarin Crimson
- Lemon Yellow
- Payne's Gray
- Neutral Tint
- Warm Sepia

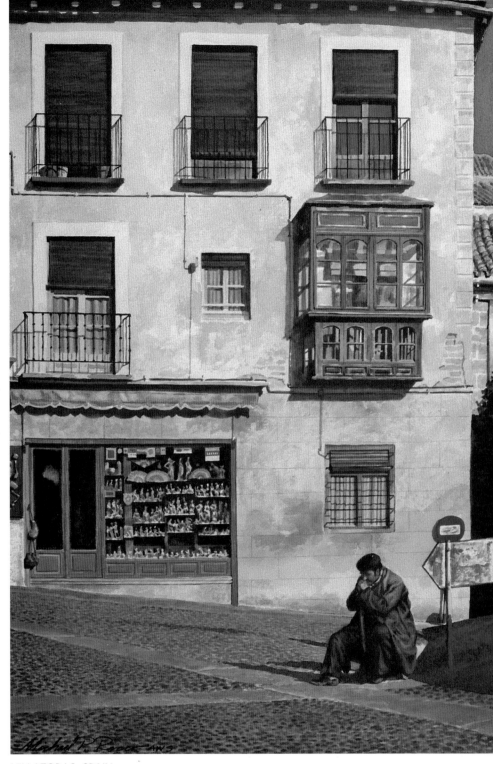

VILLATOBAS, SPAIN
21" × 14"

Index

More Great Books for Beautiful Watercolors!